The *Golden Lane*

HOW MISSOURI WOMEN GAINED THE VOTE AND CHANGED HISTORY

MARGOT McMILLEN

Charleston London
THE
History
PRESS

Published by The History Press
Charleston, SC 29403
www.historypress.net

Copyright © 2011 by Margot McMillen
All rights reserved

First published 2011

Manufactured in the United States

ISBN 978.1.60949.013.3

Library of Congress Cataloging-in-Publication Data

McMillen, Margot Ford.
The golden lane : how Missouri women gained the vote and changed history / Margot
McMillen.
p. cm.
ISBN 978-1-60949-013-3
1. Women--Suffrage--Missouri. 2. Women--Missouri--History. I. Title.
JK1911.M8M36 2011
324.6'2309778--dc22
2011012903

9/11

The Golden Lane

Research is never finished; it is only abandoned. And, then, it's dedicated. I dedicate this work to my daughters, Holly and Heather Roberson, and to my mom, Nan McMillen. Explorers of new places, we hold the lanterns for one another.

Contents

Foreword

Typically, when women walk into the voting booth, we don't think much about how we got the right to vote or the women who fought for it. We assume we have always had voting rights and always will. Partly, this is a consequence of not knowing enough about our history. In this volume, we learn the part that Missouri women played in winning the right to vote; it is a valuable addition to our knowledge of the history of women's suffrage.

Today, many politically active women are concerned that younger women are not exercising the right that women fought for so long and hard to obtain. Indeed, less than half of women under the age of thirty who are eligible to vote do so. Nevertheless, they vote in greater numbers than young men. Since the 1970s, the gap between young female and young male voters has increased from two percentage points to nearly seven in 2004. In fact, since 1980, more women than men of all ages have voted in national elections.

One of the arguments against women's suffrage a century ago was that women were not politically aware enough to vote intelligently and would take the country in the wrong direction. The opposition to women's suffrage included the liquor and brewing industries in particular, since women were the backbone of the temperance movement. Other opponents to women's suffrage were business and industry, which wanted a cheap, docile labor force, and many southern senators, who were afraid the new electorate would upset the racial status quo.

Have their fears proven true? In some measure, yes. By 1980, it had become apparent that there was a gender gap between male and female voters. The gap favored Democrats. In 1980, the gap between men and women voting for Ronald Reagan was eight percentage points. By 1996, the gender gap had risen to its all-time high of eleven percentage points. In effect, women elected President Clinton. Again, in 2008, women made the difference in the Obama-McCain race, with a gender gap of seven percentage points.

Today, some still worry about how women vote. Right wing political pundit Ann Coulter has said that she has a fantasy of disenfranchising women because they elect Democrats. John Lott, another right-leaning commentator, blames female voters for the rise of "big government" and government spending, which he says started in 1920, when women began voting. He says one of the reasons for this is that women have greater interest in government solutions to social problems.

Many people believe that most women thought suffrage would give them equality, so after 1920 they stopped working for women's rights. But Alice Paul, head of the suffrage group known as the National Woman's Party, wrote the Equal Rights Amendment. Introduced in Congress in 1923, it languished there until the 1970s, when women disrupted a Senate committee hearing to demand a vote. Though it passed Congress by a large margin in 1972, it has been ratified by only thirty-five of the thirty-eight states needed for it to become part of the U.S. Constitution.

Writers often use the passive voice when talking about women's suffrage: "women were given the right to vote." This language obscures the many years of women's work organizing, petitioning, lobbying, parading, picketing the White House and, finally, being imprisoned and force-fed. This book not only documents Missouri women's part in that struggle but also apprises us of the names of many of the women whose contributions would otherwise have been forgotten. This history should inspire all women to exercise that right so dearly won.

Mary Mosley
March 12, 2011
William Woods University

Acknowledgements

We look back and assume that women's history is the same as men's. In fact, our educations encourage us to think that way, and our books are filled with the stories of great deeds by great men, events where we think we played a part. In fact, women were often excluded from stage front. Rather, when men had a war, women cared for the wounded. When men built a business, women worked in the lowest-paying jobs.

But things change, and if we are lucky, we live long enough to see it. This book is about one giant change that took generations. I hope it increases understanding for those who, today, are working so hard against huge odds in the mere hope that they can make things better. Courage, friends. Because of work for the better, women have infinitely more possibilities than they did a generation ago. It is a mark of success that today's women can take for granted the right to vote, to be educated, to work at a satisfying job.

This book is for people who wish to understand women's courageous history. In writing it, I have learned a lot, and I have many people to thank. In the summer of 2010, three groups of writers read drafts of these pages. Thank you to Karen Barrow, Sarah Fast, Vera Gelder, Julie Kapp, Shirley Kidwell, Debra Kirchoff, Edie Maxey, Libby Peters and Gretchen Seifert. I also owe a great debt to the keepers of the collections of Missouri's many archives: Sue Rehkopf at the Archives of the University City Public Library, Ellen Thomasson of the Missouri History Museum and Greg Olson of

the Missouri State Archives. Thank you also to Kimberly Harper of the Missouri State Historical Society for directing me to the story about the American Woman's League.

And to my final readers, Pippa Letsky and Howard Wight Marshall: you are the best.

1
The Golden Lane

It was June 14, 1916; a warm, sticky Wednesday morning. The Democratic Convention would soon meet in St. Louis, at the Coliseum, the world's largest convention center. Inside the Jefferson Hotel, the men ate breakfast and met with their committees. Perhaps they chatted about the war in Europe, noted that Woodrow Wilson had the election locked up or remarked that the bread was darn fresh. The freshness of the bread might have led to praise for the city, with its modern lights and purified water, skyscrapers and electric streetcar system. Delegates might even have expressed surprise, comparing St. Louis to cities on the East Coast, the West Coast and, of course, its Midwest rival, Chicago.

The comings and goings of delegates and spectators added to the traffic, noise and bustle of the city street. Aromas from the restaurants, automobiles, horses and harness and coal smoke from the electric plant gave the place a distinctive gritty odor. Now, outside the hotel, thousands of women quietly took their places on the sidewalk. By ten o'clock in the morning, they were lined for blocks along both sides of Locust Street, shoulder to shoulder, each in a dress that brushed the pavement, shading herself with a yellow parasol and wearing a yellow sash that read, "Votes for Women."

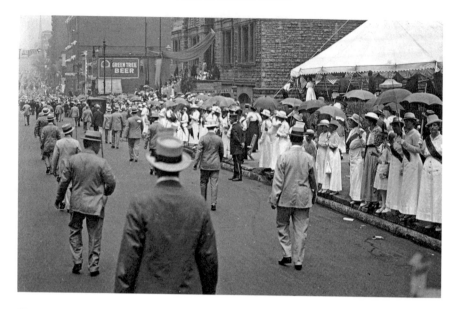

These men are marching with their club, wearing matching hats and suits. They seem to rush down the city street between the lines of resolute women in their long dresses and yellow parasols standing in front of the brick and stone skyscrapers. *Carrie Chapman Catt Papers, Special Collections Department, Bryn Mawr College Library.*

The "Golden Lane" spread for a mile on both sides of Locust Street, forming a peaceful "walkless, talkless parade" with women from all over the nation. The message was clear: We have made every reasonable argument, time and again, to prove that we carry the burdens of modern life just as men do, and we are capable of voting responsibly. Still, our pleas are rebuffed, ignored and met with insults. Our parades are blocked by ruffians; some demonstrations become violent, and it is the women who are jailed.

This public demonstration by women in the city was daring, even shocking. St. Louis was riddled with divisions—between ethnic groups, racial groups, southern and northern U.S. traditions and a political machine controlled by the beer-brewing industry. Two years earlier, the suffragists' petition drive had been rudely scorned by the state legislature. Suffragists risked censure and exclusion from all sides, so they pursued the goal of voting in modest, ladylike tones. Although the organizers had prepared for months, and the Golden Lane was no secret, the reality of women standing silent on a downtown street had an astonishing impact.

The Golden Lane

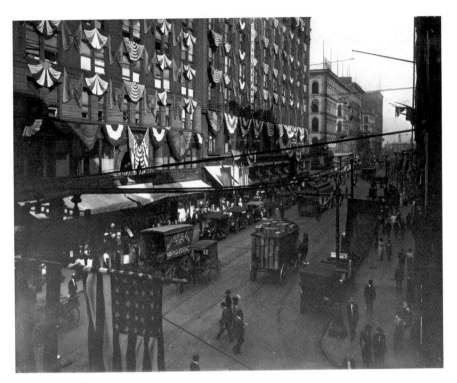

Washington Avenue looking east from Seventh Street, about 1912. Decked out for a festive occasion, the best downtown streets were modernized for the World's Fair and boasted electric lights. Washington Avenue had space for streetcars, carriages and automobiles, with wide sidewalks. In contrast, some downtown streets were dark, dirty and narrow, unsuitable for transportation larger than horse-drawn wagons or carriages. *Missouri History Museum, St. Louis.*

How did this Golden Lane come about? Who planned it? Who was there? The answers go back to the American Civil War and earlier, when St. Louis was the Gateway to the West and (at least to the city leaders) the commercial center of the world.

2
Spheres

I never want to see the women voting, and gabbling about politics, and electioneering. There is something revolting in the thought. It would shock me inexpressibly for an angel to come down from above and ask me to take a drink with him (though I should doubtless consent); but it would shock me still more to see one of our blessed earthly angels peddling election tickets among a mob of shabby scoundrels she never saw before.
—Samuel Clemens (Mark Twain), letter to the St. Louis Missouri Democrat, *March 1867*

Until 1800, St. Louis was part of the French empire, and the French legal system allowed women freedoms such as owning property and divorce. Women were valued for their resourcefulness. Marie Thérèse Bourgeois Chouteau, a founder of St. Louis, was one of many French women in St. Louis who were skilled in business. There were many other resourceful women—French, free black, Native American, European and Anglo-American. During these early settlement years, without women's wit, the pioneer family would not have survived.

The Boone family left a record about the importance of women. When Nathan and Olive Boone came to Missouri in 1799, they both knew Nathan would spend most of his time camping and hunting on the frontier while Olive took care of the home place (near present-day Defiance). The

first time Nathan left her alone with a slave girl for company, they had only a small, leaky log cabin. Olive was eighteen years old and pregnant, in a home where the dirt floor turned to mud in a rainstorm. So the young women built a floor for the cabin. When the weather turned cold, the young women cut a hole in the building and built a stone fireplace and chimney, using mud and sticks for mortar. They tended to cattle, planted crops, chopped wood, hauled water and did the cooking. When there was work to be done, the women knew they could do it.

A pioneer woman was resourceful because her life depended on it. But in the age of industrialization, factories started producing food and clothes, which had previously been household jobs. Turning women into consumers certainly suited the factory owners who were making household goods, but the shift changed traditional roles. Households now needed more money and less resourcefulness, and with the social disruption came a need to reconfigure gender-based roles.

With the Louisiana Purchase, Missouri laws changed to fit American society. According to the new philosophy, there was a natural separation of the "spheres" inhabited by men and women. True Men were to take care of matters such as government, finance and business, while True Women were to take care of the families' happiness, comfort, economies and social relationships.

The German philosopher Johan Wolfgang von Goethe (known as Goethe), author of numerous books and plays, including *Faust*, came to the subject early. His writings, popular long after his death, idealized the role of women in the home as opposed to men's role in the rougher world of commerce. *Godey's Magazine*, a women's journal that boasted readership of 150,000 women in the 1850s, printed:

> *Women often complain that men are unjust towards their sex, in withholding from them higher mental culture, and in not allowing them full access to the sciences, thus keeping them down to mere household duties, and to the government of the domestic circle. It is, however, unjust that man, on this account, should be the subject of complaint. For has he not placed his wife in the highest and holiest position she can occupy when he places her at the head of his domestic relations, and intrusts [sic] to her the government of his household?*
>
> *When a man is harassed by external duties and relations, when anxiously employed in procuring the means of subsistence, and when he even takes*

part in the government of the state—in all these conditions of life he is dependent on circumstances, and can scarcely be said to govern anything, but is often reduced to the necessity of acting from motives of policy, when he would gladly act from his own rational convictions...Whereas, the prudent woman reigns in her family circle, making happiness and every virtue possible, and spreading harmony and peace throughout her domain.

Notice that Goethe's argument describes a woman's life that doesn't include any real jobs. He continues, "She is dependent on nothing, save the love and attachment of her husband, for whom she procures true independence—that which is internal and domestic. That which his labor has acquired, he sees properly secured and employed." Indeed, Goethe's model left a woman in a precarious position. If she had no husband, or if her husband died, she and her children were doomed.

In a large city and unlucky enough to have no husband or friendly kinfolk, women had few options. Younger women might become prostitutes or even die on the streets. Those with skills might become seamstresses in sweatshops or laundresses. These St. Louis beggars had a music box. As the industrial age proceeded, there was ever more reason for women to desire power in the marketplace and lawmaking. *Library of Congress.*

One famous Missouri mother, Jane Clemens, was raising four children when her husband died in 1847. Orion, aged twenty-one, became the head of the household and found a place for the family to live. Pamela, aged twenty, taught piano lessons. Henry and Sam stayed in school and bounced from one after-school job to another. The family managed to stay together. When Jane found an apprenticeship for Sam that paid nothing but provided room and board, she was relieved of one mouth to feed. Sam, of course, learned the printing business quickly, writing under several pen names, including Mark Twain. In river-town Hannibal, with male relatives around, Jane Clemens was lucky. Her life as a single mother was far from ideal, but she was able to survive and keep the family together.

The model of the ideal life in the separate spheres was only available to a prosperous few men and women. For the majority, separation of the spheres meant that both sexes lived in ignorance of the other. This was hard for men as well as women. Whether he worked in a profession or as a laborer, a widowed man could not make sure that his children were fed and educated. This was a time when many women died in childbirth. Convinced that homemaking was the woman's sphere, fathers had little interest in or knowledge of raising children. Many children were abandoned to the streets. With no public schools, education was out of the question for these orphans. The cycle of poverty was ironclad, and women had no way to change policy.

By the middle of the 1800s, the city had immediate problems of disease, poverty and crime. Poor food quality and problems of cruelty in the factories, including child labor, had caught the attention of women, who at the time were beginning to gain education, leisure and the ability to speak out. These women were beginning to question their roles in society. In 1854, Clarinda Nichols lectured about women's rights in St. Louis. She reported that the audiences were "intelligent and respectful." But the river town, crowded with new residents and grappling with the challenges of its new population, was not ready for a discussion led by this woman from Vermont; the question would lie dormant. By the time Clarinda Nichols spoke, the American Civil War seemed almost inevitable, and St. Louis society was drawing its boundaries. The loyalties of many old St. Louis families were divided, with some members favoring the Union and others siding with the Confederacy. It would turn out that, for the size of its population, Missouri supplied more men to the various military organizations than any other state. More Missouri men joined the Union than the Confederacy. St. Louis

would be important to both sides because river traffic was the main way to supply the armies.

Still, in terms of economic well-being, Missourians knew they would be better off staying neutral in the conflict. St. Louis had a special problem because the governor of the state, Claiborne Jackson, was a Southern sympathizer while St. Louis was dominated by Captain Nathaniel Lyon, who commanded the Federal Arsenal. The city of commerce, once a vigorous and lively town where people of many races and opinions had their roles, became a ghost town. Jessie Benton Fremont remembered:

> *In '61—the beginning of war. Everything has changed. There was no life on the river; the many steamboats were laid up at their wharves, their fires out, the singing cheering crews gone—they, empty, swaying idly with the current. As we drove through the deserted streets we saw only closed shutters to warehouses and business places; the wheels and the horses' hoofs echoed loud and harsh as when on drives through the silent streets late in the night…It was a hostile city and showed itself as such.*

Jessie Fremont was a writer and an adventurer, the daughter of Senator Thomas Hart Benton. Her husband, John Charles Fremont, became commander of the Federal Department of the West during the war, and Jessie served as his assistant. She helped organize the Western Sanitary Commission (WSC), founded after the Battle of Wilson's Creek and headed by banker and philanthropist James Erwin Yeatman. She brought her friend Dorothea Dix to St. Louis to help the WSC care for the wounded. She went to Washington in 1861 to plead with Lincoln for immediate emancipation of the slaves. He responded in what she called a "sneering" tone that she was "quite a female politician." She wrote to friends that Lincoln was a "sly, slimy" man with a "tenderness toward slavery."

There were many women who began their public work during the Civil War and then became active in the suffrage cause. Anna Lansing Clapp was born and educated in New York and moved to St. Louis just before the outbreak of the war when her husband, Alfred Clapp, became president of the Missouri Mining Company. She founded the St. Louis Ladies Union Aid Society (LUAS) in 1861. In the divided city of St. Louis, the LUAS required members to show proof of Union loyalty and operated almost in secret.

The LUAS maintained an office at City General Hospital and volunteered with the WSC as thousands of wounded soldiers came to St. Louis hospitals. The women cut sheets and clothing into strips for bandages and rolled them into neat coils for the doctors. They raised money for medical supplies, clothing, blankets and food. In the early days of the Civil War, LUAS members helped only Union soldiers and their families. In November 1863, their mission changed to include Confederates. They saw firsthand the ravages of war and the poverty of widows and children as they visited the sick, read to the soldiers and held the hands of the dying.

Under Anna Clapp's leadership, members of the LUAS published daily summaries of work and annual reports. In 1863, the women reported, they were visiting the WSC Refugee Home, the Gratiot Street Prison Hospital and 684 destitute soldiers' families. They staffed the kitchen at Benton Barracks, serving 19,382 meals between May and October, financing their work with fundraisers and donations. They won a government contract to cut and assemble hospital garments, putting 500 soldiers' wives to work. They raised over half a million dollars for the WSC.

Thousands of newly freed slaves, mostly women and children, came to St. Louis in 1863 and were housed in the Benton Barracks and the Missouri Hotel, severely straining city services. Rebecca Naylor (Mrs. William T.) Hazard, a mother of five, moved from Ohio to St. Louis just before the war. She became treasurer of the Freedmen's Relief Society, raising money to establish a hospital. With a letter in the newspaper, she singlehandedly raised $3,000. Hazard later wrote that the "cruel war had much to do in educating the women of Missouri into a sense of their responsibilities and duties as citizens."

So seeds of suffragist work can be found in the Civil War. Adaline Couzins, wife of the St. Louis police chief, and her daughter, Phoebe, would work for the LUAS and then join the fight for suffrage. Phoebe Couzins would become a national figure in the movement, arguing that women should be allowed to vote because of the service they gave their country during the Civil War. When an invitation came for a suffrage speaker, Phoebe Couzins would go, and she became a fiery evangelist for the cause. Traveling to Fulton in 1870 by railroad, stagecoach and skiff across the Missouri River, she spoke at Westminster College, where "the daughters of Missouri are forbidden to enter save as meek listeners to the profound wisdom and logic of the male." She would soon after gain a law degree as the first female

graduate of Washington University, the only law school in the nation that accepted women at the time.

"Woman should hasten to repair her ignorance of laws and needs, by a thorough knowledge and acquaintance of those which govern her and affect humanity," wrote Phoebe Couzins in "A Speech by the Lady Bachelor at Law." She argued that bringing women into the modern age was a matter of survival for the nation:

> *She has been regarded as created for man's self-love, alone; with no soul to feel, no mind to expand, no brain to weigh argument, no individual accountability to render her Maker, and thus the race has slowly, painfully climbed the heights of progress, dragging a dead weight… Woman's irresponsibility and man's culpable negligence is working ruin to our social and political fabric; and, unless some power can galvanize the slumbering virtue of this people into new life, we, as a nation, are doomed to irresistible disaster.*

Another of the members of the LUAS was Virginia Minor, a prominent member of the organization who would carry her battle all the way to the U.S. Supreme Court. To understand the journey of Missouri women, we must spend a bit of time with Virginia Minor.

3
The Legal Status of Virginia Louisa Minor

What are not *the rights of Women, according to the best authority? It is* not *their right to speak in public assemblies. "Let your women keep silence in the churches." "Suffer not a woman to teach or to usurp authority over the man." And, "be keepers at home," says St. Paul…We should infer from this that it is* not *her right to strive for places of political distinction among men.*
—Valley Farmer, *St. Louis, 1851*

Virginia Louisa Minor was born on March 27, 1824, in Caroline County, Virginia. Her family valued education for women. When she was a toddler, her father became innkeeper at the University of Virginia, and she, along with six siblings, was educated in that academic environment, mostly at home and with a brief term at an academy for young ladies. In the one surviving portrait of Virginia Minor, she appears as a sweet-faced woman with an alert expression, her hair pulled back in a barrette. She is dressed modestly in a dark dress with a white scarf around her neck secured by a pin. There is perhaps a pair of glasses pinned to her dress—it's hard to tell for sure. These are probably her best clothes, at a time when people had only two or three outfits, with one reserved for special occasions. If we could see Virginia in full view, we'd see that her dress, which has a bit of pattern in the material, is shaped by a whalebone corset and a full skirt reaching the floor. The constriction probably forced her to take small, ladylike steps.

At nineteen, Virginia married a distant cousin, twenty-two-year-old Francis Minor, who had been educated at Princeton and the University of Virginia Law School. When she married, Virginia Minor's status changed from being Virginia Minor to being Mrs. Francis Minor. Some women lost their identities so completely that their first names were remembered by only a few close friends and family. As a wife, she could not buy or sell property in her own name, make a contract, sue or be sued, have legal guardianship over a child, inherit property or claim her own wages. Instead, husbands and wives were legally "one person," and that person was the husband.

The couple moved to Mississippi for a year and then to St. Louis. Although both the Minors had southern roots and had come from prosperous landowning families, they brought no slaves to Missouri, and they didn't own any after they arrived. They had plans for Francis to be a lawyer, and they found opportunity here: a frontier town, agricultural center and trading and transportation powerhouse. While St. Louis had been founded by the French, who still had a considerable presence, there were many population groups. Americans, from both the northern and southern states, sought the promises of trade and industry. A German population was well established; into their neighborhood came Irish immigrants escaping the potato famine at home.

St. Louis was grappling with an exploding population and few services. From a tiny village of 4,977 people in 1830, it had more than tripled in the next decade to 16,469. Then, between 1840 and 1850, the city jumped from twenty-fourth to become the eighth-largest American city, with 77,860 residents.

The area around Soulard, St. Louis's oldest neighborhood, was crowded with new German and Irish populations and boasted a number of taverns and beer halls, each using recipes from the old countries. At least forty of these breweries became large enough to be memorable, and it was inevitable that at least one brewing family would innovate their way into prosperity. John Lemp found that the cool limestone caves under the city provided the perfect environment for aging his lager. He passed his fledgling business to his son, William. When the Civil War broke out, other breweries went out of business, and Lemp's became the largest in St. Louis. The Lemp mansion was built with materials from around the world—Italian marble and African mahogany—and included a heated swimming pool. The family history, however, was marked by tragedy, as one member after another committed suicide, and the Lemp success was eclipsed by another family.

The Legal Status of Virginia Louisa Minor

In 1860 Eberhard Anheuser, a soap maker, bought a brewery owned by George Schneider and named it E. Anheuser & Company. A year later, Adolphus Busch, a successful and creative businessman born in Germany, married Anheuser's daughter. A born salesman, Busch came up with new promotions. Rather than present customers with a business card, for example, he gave each a pocketknife engraved with the company name and, in a tiny peephole, a portrait of himself. What a great gimmick! In the 1870s, with the inventions of pasteurization, bottling, railroads, double-walled railcars cooled with ice and a network of icehouses to keep beer fresh, the Busches started shipping their beer. Budweiser became America's first national brand.

While beer brought fame to St. Louis, it was accompanied by a national epidemic of alcoholism among men, many of whom became addicted in the Civil War. Belief in the "men's sphere" and "women's sphere" kept the sexes separate, and each sphere kept secrets that only members could share. The drinking of liquor was part of the men's secret world.

Male social clubs hid alcoholism because reputable women were not allowed to enter, or even be downtown, after dark. Some brotherhoods—like the Elks Club, founded right after the Civil War as the "Jolly Corks"—provided refuge from wives trying to retrieve their husbands before the paychecks were completely spent. In the effort to close "joints," women often had the law and the church on their side, but there was a powerful and growing coalition of drinkers and saloon owners.

Social chaos was spurred on by other conditions of urban life. Like other growing cities, the St. Louis sanitation system was nearly nonexistent. Disease was rampant, and in 1849, a cholera epidemic killed 10 percent of the residents. The few social services could not handle all the widowed mothers and fathers or their orphaned children.

While Francis Minor established his law office, Virginia constructed a household. They first purchased a house in the city. Then, after the birth of their son, Francis Gilman Minor, they purchased ten acres on the outskirts of the city. In an interesting move that reflects both Francis's legal training and his agreement that women should have rights, their property was put into a trust under Virginia's name. The list of personal property in the trust gives us an idea of their possessions:

Six mahogany chairs, one mahogany rocking chair, one spring bottom sofa, three carpets and oil cloth, one hearth rug, one girandole [fancy candlestick], *one*

card table, one writing desk, one wardrobe, one bedstead, one cooking stove and apparatus, one dining table, one bureau, one dozen common chairs, one wash stand, one feather bed, one bathtub, two ottomans, one set of silver tablespoons, one set of silver teaspoons, one set of silver forks, one pair of silver sugar tongs, one gold watch and the Library, according to the catalogue of Books.

Creating a trust to protect a couple's assets was fairly common among privileged St. Louisans. In fact, under any other legal agreement, a woman would not have any right to the family property if her husband died. His property would go to another man, a brother or a brother-in-law, perhaps leaving her in poverty. Many historians have noted that, indeed, married women were legally dead. By putting their property in trust, Francis and Virginia protected their assets and were also building their own partnership in an uncertain time.

The United States ended slavery with the Thirteenth Amendment. For St. Louis, the declaration of peace was joyous, but soon after the end of the war, the Minors were consumed with grief when their fourteen-year-old son was killed in a shooting accident. Virginia poured her energy into working for votes for women and pulling together her network of friends from the LUAS. She was already experienced in organizing friends to work for the vote. In 1866, she had written a note to Senator B. Gratz Brown to thank him for supporting suffrage and persuaded several friends to sign on.

Rebecca Hazard, Lucretia Hall, Penelope Allen and LUAS president Anna Clapp organized the first meeting of the Woman Suffrage Association (WSA) of Missouri on May 8, 1867, in the directors' room of the Mercantile Library. This meeting could not have happened without the help of several prominent men who were sympathetic to the cause. Supporters included James Erwin Yeatman, serving as first president of the Mercantile Library; Wayman Crow, founder of Washington University; and other associates of the library, the university and the Unitarian and Presbyterian churches.

Virginia Minor joined the new group and was elected president. The WSA was the first organization in the world to make votes for women its exclusive goal, and Virginia served as WSA president for five years. Under her leadership, St. Louis became a center for suffrage activism. And a few months after the WSA was formed, the Mercantile Library hosted Susan B. Anthony, the tireless worker for suffrage and founder of the National American Woman Suffrage Association.

WOMAN'S SUFFRAGE IN ST. LOUIS.

ST. LOUIS, Mo., May 13.—As the result of the Woman's Suffrage Convention held here last week, several women interested in procuring the ballot for women, and placing them on an exact equality with men with regard to rights of citizenship, met here to-night and organized the St. Louis Woman's Suffrage Association. The following officers were elected: President, Mrs. Virginia L. Minor; Vice-Presidents, Mrs. Eliza J. Patrick, Mrs. Mary C. Todd, Mrs. Phœbe W. Cozzens; Secretary, Miss Eliza B. Buckley; Treasurer, Miss Maggie Baumgartner.

From the New York Times.

The Missouri suffragists could see two avenues to success. One option was to gain a women's suffrage amendment to the state constitution. The other was to seek an amendment to the U.S. Constitution. In 1868, Congress adopted the Fourteenth Amendment to prevent states from giving blacks fewer rights than white Americans, saying, "No State shall make or enforce any law which shall abridge the privileges and immunities of citizens of the United States." This amendment, which did not define "citizens" as "males," gave women hope that they could vote and affirm that the federal law would be supreme. The WSA circulated a petition that went to the state legislature. The petition, with its 350 signatures, asked that the Fourteenth Amendment to the Constitution be extended to Missouri women. The legislature rejected the petition, eighty-nine votes to five. In the Civil War, the issue of a state's rights to make laws had been bitterly contested, and for women, the contest would continue.

On the national level, Susan B. Anthony, Elizabeth Cady Stanton, Abby Hopper Gibbons and Elizabeth Smith Miller sent a letter to the Republican National Convention asking for a women's suffrage plank in the presidential platform, to reward women for their service during the Civil War. Their letter was ignored. They were jeered at when they appeared before the Democratic National Convention with the same request. But from this point onward, women appeared at every convention, asking both major parties for

endorsement. They were met with laughter, silence or a respectful but empty statement in the party minutes.

The Fourteenth Amendment did not specifically address voting, so another amendment was passed in 1870 that stated, "The right of citizens of the United States to vote shall not be denied or abridged by the United States or by any state on account of race, color, or previous condition or servitude."

The definition of "citizen" was (again) left out, and there was (again) no mention of women. The National Women's Suffrage Association was founded in 1869 (the Minors and Phoebe Couzins belonged) and opposed ratification of the Fifteenth Amendment because it did not extend votes to women. In fact, the amendment would become divisive when women got no help on the issue from the black community. Remembering their part in the war, women expected that blacks would stand up for them. African Americans, however, were occupied with their own struggle for rights. Black women were particularly burdened by life, which discriminated against women in general and was also harshly segregated by skin color.

There were also divisions among the suffragists. Besides the National Women's Suffrage Association, a second group, the American Women's Suffrage Association, supported the Fifteenth Amendment on the grounds that change in voting rights would come about incrementally. Wyoming Territory had by now approved universal suffrage, and Utah Territory would soon follow.

The Minors took their mission seriously. In 1869, Virginia spoke at a national suffrage convention in St. Louis, saying, "The Constitution of the United States gives me every right and privilege to which every other citizen is entitled." Later that year, the Minors wrote and distributed pamphlets arguing that the state was taking away women's rights granted by the Fourteenth Amendment. They became vocal leaders in a nonviolent civil disobedience movement that motivated hundreds of women to attempt to vote in various parts of the country. And in a few cases, the strategy worked. A Michigan woman voted in 1871 after officials allowed her to register, and she voted without question for several years. In Rochester, New York, Susan B. Anthony was successful in casting a vote in 1872 but was arrested three weeks later and charged with fraud. When her case came to trial, the judge wrote his opinion before the trial even started and directed the jury to find her guilty. She was ordered to pay $100, and she refused.

In Missouri, there was enough gray area in the state law to allow women to vote if a registrar allowed it. In 1857 and 1865, Cooper County taxpayers

voted on the question of running a railroad between Boonville and Tipton. Voting was allowed without incident for African Americans and for women.

The Cooper County votes were cast on local issues, with voting allowed by the local jurisdiction, but voting for state government issues or electing America's president was different. In 1872, Mrs. Minor appeared before the St. Louis registrar of voters and tried to register for voting in the presidential election. She was a citizen, free, native born and more than twenty-one years old. The registrar, Reese Hoppersett, turned her away. As a woman, Mrs. Minor could not take the registrar to court, but with her husband, she was able to sue for damages. The Minors argued:

> *All persons born or naturalized in the United States and subject to the jurisdiction thereof are citizens of the United States and of the State wherein they reside. No State shall make or enforce any law which shall abridge the privileges or immunities of citizens of the United States; nor*

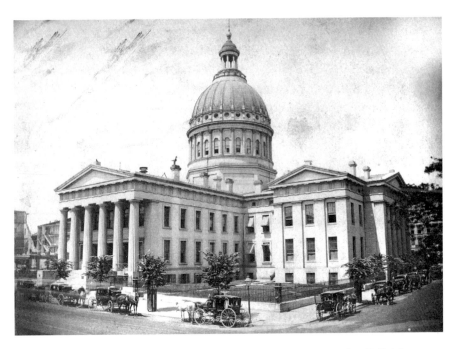

The courthouse was the most imposing building in St. Louis in 1865, when R.F. Adams took this photograph. Francis Minor worked here as clerk of the Missouri Supreme Court until he and Virginia brought their case. His experience would have made him a familiar figure here, but Virginia, as a woman, was an outsider. He presented her case here and before the U.S. Supreme Court. *Missouri History Museum, St. Louis.*

shall any state deprive any person of life, liberty, or property, without due process of law; nor deny to any person within its jurisdiction the equal protection of the laws.

The Minors lost, and they appealed the decision to the Missouri Supreme Court, where they lost again. Then they appealed to the U.S. Supreme Court, stating, "There can be no half-way citizenship...Woman, as a citizen of the United States, is entitled to all the benefits of that position, and liable to all its obligations, or to none." The Constitution "nowhere gives [states] the power to prevent" a citizen from voting. The Supreme Court ruled unanimously against the Minors. The decision was released on March 29, 1875. "There is no doubt that women may be citizens," wrote Chief Justice Morrison Remick Waite, summing up the opinions of the court's nine white males. He continued by saying that women had always been citizens, but the question was whether all citizens were entitled to vote. Waite reasoned that the context of the Constitution had to do with the original thirteen colonies. When it was adopted, women could vote only in New Jersey. And when women's votes nearly unseated a New Jersey politician in 1797, that politician made sure to repeal their right. Every other state had banned women from voting. Therefore, Waite said, the right to vote was not a privilege of citizenship but a right conferred by states, and a state's denial of the right did not interfere with the U.S. Constitution.

This states' rights decision was reexamined and argued by suffragists and anti-suffragists alike. Phoebe Couzins referred to it often, saying the decision gave the state "supreme authority and [overthrew] the entire results of the War, which was fought to maintain national supremacy over any and all subjects in which the rights and privileges of the citizens of the United States are involved."

After this court decision, women renewed their efforts. In 1878, Senator A.A. Sargent of the state of California introduced yet another attempt at a new amendment: "The right of citizens of the United States to vote shall not be denied or abridged by the United States or by any State on account of sex." This "Susan B. Anthony amendment" would fail. It was reintroduced every year for decades.

The next year, a national suffrage convention brought men and women to St. Louis. The mayor, Henry Overstolz, "was impolite enough to decline to deliver the address of welcome, and this action met with hot

disapproval, strongly expressed," the *New York Times* reported. Overstolz was a controversial figure who owed his success to the Busch family. He was the first German-born politician elected to office in St. Louis.

Perhaps as a reaction to Overstolz's snub, the convention approved a declaration that "the right of self-government…was the birthright of the native citizen and the acquired right of the adopted citizen." The declaration asserted that, "under decisions of the United States Supreme Court, the male African is the only United States citizen who holds the ballot in every State" and added, "While women are not permitted to vote[,] the legislation of the country is defrauded of one-half of the intelligence, virtue and practical wisdom of the nation." The suffragists demanded an amendment to the Constitution, "defining the rights of citizenship and suffrage so clearly that even the Supreme Court can understand them."

The success of this convention led to the establishment of a new association, the St. Louis Suffrage Association. Virginia Minor was president (now age fifty-five), and the three vice-presidents were Mrs. Eliza J. Patrick, Mrs. Mary C. Todd and Phoebe Couzins. Eliza Buckley served as secretary, and Miss Maggie L. Baumgartner was treasurer. Virginia Minor remained dedicated all her life. She testified in support of women's suffrage before the U.S. Senate ten years later. In 1892, in failing health, she was honorary vice-president of the Interstate Woman Suffrage Convention. When she died in St. Louis in 1894, her will was published in the newspaper, with a note to explain some odd bequests: one-half of her estate was left to Susan B. Anthony, "in gratitude for the many thousands she has expended for women." The other half was split between two independent women—unmarried nieces—with instructions that if one married, she should give her part to the other.

It would be years before women's suffrage became reality, but Virginia Minor had played her part well. As the *St. Louis Republican* noted, "She is best known to the public in this connection, having lived out her long life in the furtherance of the women's suffrage movement, being hand-in-hand with Miss Susan B. Anthony, Mrs. Lucretia Mott, Mrs. Julia Ward Howe and Mrs. Elizabeth Cady Stanton."

4
Women's Clubs

During the first year under the new Wednesday Club structure, former Shelley Club members prepared essays on the Lake Poets, but the board also chose Christian Socialism, child labor, compulsory education and "The Fellowship of Women" as program topics.
—*Katharine T. Corbett,* In Her Place: A Guide to St. Louis Women's History *(Missouri Historical Society Press, 1999)*

By 1870, St. Louis was the fourth-largest city in the nation, behind New York City, Washington and Boston. When the 1880 census was taken, St. Louis's boundaries had become fixed (the city had separated from the county), and the younger city of Chicago had pushed St. Louis down in rank. Still, there was no doubt about it, Missouri was an industrial power. The state was rich with resources such as iron, clay to make brick, coal, sand for the glassmakers, stone, timber, farmland and a ready supply of immigrant labor.

Horse-drawn streetcars had come to St. Louis before the Civil War, running on Olive Street between Fourth and Tenth Streets. Soon after the Civil War, double-decker streetcars appeared. The transportation industry innovated constantly, with steam-powered cars and, a decade later, electric. From its old downtown by the river, St. Louis marched west along a grid of new avenues flanked by handsome brick buildings built on massive stone

foundations. The scene was modern, handsome and masculine. Heavy things were moved to create the huge buildings—cobblestones, cinders, brick—with nary a stray twig of grass or a tree in sight. In fact, as buildings and lots along the river declined, the first signs of their demise were graceful weeds and willow sprouts.

With their husbands downtown and household labor plentiful, women now had time to devote to self-improvement and neighborhood betterment. Women's clubs sprung up around all interests, offering diversion and a way to enjoy afternoon leisure. At a meeting in a home, the hostess had a chance to show off her creativity and skill at homemaking, and at a meeting in a public space such as a library or an auditorium, she could still display her manners and fashion. Attending lectures by experts from their communities and beyond, club women studied art, music, science, ancient civilizations, prison reform, pure food laws and other family issues. Prosperous women found ways to stand up for the less fortunate. In 1870, St. Louis legalized prostitution, thinking it might be monitored if prostitutes had to register. Women of means pointed out the dangers and worked to recriminalize the behavior.

One problem solver, Ariadne Worthington Lawnin, helped establish the Women's Christian Association for "self-supporting girls"—often rural youngsters who had come to St. Louis to find success. Adopting the motto, "Help Those Who Try to Help Themselves," the WCA helped the girls locate safe places to work and board and also provided teachers in the arts of sewing, cooking and needlework. Besides classes, the WCA provided a tearoom and a library, places for the young women to relax and form friendships. The association sold high-quality materials at wholesale prices and established the Women's Exchange to sell fine handiwork, moving the exchange often to keep up with the shifting neighborhoods of the St. Louis wealthy, who could buy it.

Board members were required to volunteer many hours a month. An article about the founders in 1883 states, "Starting out upon the principle that there could be no greater charity than helping those who try to help themselves, the ladies are bound to succeed if the earnestness of intent and never failing attention to detail can guarantee success."

In 1879, the city's first department store, Barr's, opened at the corner of Sixth and Locust, bringing women downtown to buy furniture and clothing. Their carfare helped support the streetcar industry. Businesses took note.

By 1881, the city boasted more than one hundred miles of streetcar track. The St. Louis Cable & Western cable car began operations in 1886, running on Franklin Avenue and forcing the city to expand the electrical grid to run new lines. Legislation in 1891 would create the wide boulevards of Lindell, Delmar, Washington, Page, Forest Park and Union. These became the major thoroughfares, connected by new cross roads and moving the wealthy toward Forest Park.

Along the new roads, each owner worked to create the most modern and impressive building, usually with retail space on the first floor. The Wainwright Building, built for a successful brewer, was one of the first steel-frame buildings in the world, setting a new standard and rising to ten stories. Large doors at street level drew in the curious, and architect Louis Sullivan framed the huge windows with fancy brick and stone. Shopping was becoming a national pastime, and women had the opportunity to become sales clerks. This was a tiny crack in the male economy, but it would widen.

St. Louis was a major hub for the railroads, and as the railroads grew, so opportunities grew for women to join the wider world. The year after the Supreme Court judgment against Mrs. Minor's right to vote, Fred Harvey opened the first of his restaurants, which became among the first restaurants to hire women. Harvey Girls left their rural communities and arrived in railroad towns. Some even settled in the unknown territories of the West, drawn by their spirit of adventure (and perhaps the chance these places offered for women to cast a vote).

Railroads could take you new places, but for neighborhood travel, credit goes to the bicycle for bringing huge changes—particularly in women's fashion. There had been efforts to change the cumbersome long skirts and constricting corsets as early as the 1850s, but when the first bicycles appeared in the United States, men and women agreed that the long skirts of Virginia Minor's day would not do. Medical experts debated whether the pleasure and convenience of bicycling outweighed the dangers, especially for women with yards of material flapping around their ankles. By the 1880s, women were trying more suitable clothing, experimenting even with trousers. Women's magazines wondered whether one could be ladylike after abandoning the corset, but bicycling for health and exercise became a way for women to expand their horizons past their homes.

For the most part, suffrage leaders had successful husbands who could support them in comfort. They came from families where education was

valued for both women and men. Like Virginia Minor, these women were the family managers and bookkeepers while their husbands ran the businesses. They might stay home much of the day, but things were changing.

The first women's organizations came from church relationships, helped along with support from the Protestant clergy. Soon, they would attack the perils of alcohol. In 1874, the first convention of the Women's Christian Temperance Union (WCTU) was held on the Chautauqua Grounds at Chautauqua, New York. Less than a year later, the first national WCTU convention was held in Cleveland, Ohio. This quickly became the largest women's organization of its time. The WCTU blamed alcohol for family breakups, unfair labor practices, child poverty and every threat to society. If something was good, it argued, it should not become an obsessive indulgence. If something was bad, it should be avoided. The women found allies in several states, including Missouri.

As their initial temperance message went unheeded, members of the WCTU went on to demand prohibition. The WCTU worked to close saloons and the offending men's clubs. Together with clergy, the women marched to these establishments to sing hymns and pray outside the doors, as loudly as possible, with the aim of disrupting business and driving out the drinkers.

An ardent prohibitionist, Carrie Nation was raised on the Missouri border during the Civil War. The family moved between Missouri and Kansas during this painful time, and young Carrie married a man who became addicted to alcohol while being treated for a war wound. She became pregnant and, when her husband died, tried one strategy after another to provide for her child. She wrote that she prayed for a husband, and her prayer was granted. In her second marriage, to David Nation, she came back to Kansas as a preacher's wife. Wanting to live a life of service, she visited prisons and concluded that all crimes were caused by addiction to alcohol. The Kansas WCTU had won a law in 1881 to make Kansas dry, but the law was not enforced. Carrie became devoted to its enforcement. First, she tried closing saloons by peaceful means, taking groups to sing hymns outside the saloon doors. Soon, crowds were entering the spaces and smashing the liquor bottles and casks with hatchets and axes. A tall woman, Carrie was an imposing figure and a natural leader who soon drew crowds. Convinced of her mission, she changed her name to "Carry A. Nation." She was repeatedly beaten and jailed for her actions, but prohibition remained her first cause. "The Bravest Woman in Kansas," as she was known, also

remained convinced that "the loving moral influence of mothers must be put in the ballot box."

In direct opposition to the WCTU was the U.S. Brewers Association. When it held its meeting in St. Louis in 1879, the city was thriving. The Eads Bridge had been completed just a few years earlier and now linked St. Louis to Illinois, Chicago and the East. More than twenty-five St. Louis brewers were prospering, and the city was entering, with full credentials, the Gilded Age. In a few years, Adolphus Busch would be earning nearly $2 million a year. Prohibition presented a constant threat to the industry. Women, especially WCTU members, were seen as the enemy.

By this time, women began to suspect that men were refusing them the vote because the issues of suffrage and prohibition were entwined. Indeed, as they later learned, brewers were open in their fight against prohibition but secretive when it came to fighting women's suffrage. According to a history of the suffrage movement written by Carrie Catt and Nettie Rogers Shuler, in 1881 the Brewers' Convention included the adoption of an anti-suffrage motion—on the basis that prohibition, if passed, would be easy to repeal, but suffrage would be impossible to repeal because women would be able to vote on it. To keep from being questioned about this later, the brewers kept no written minutes.

Despite the opposition, or perhaps because of it, the WCTU grew from 22,800 female members in 1881 to 138,377 in 1891, the most popular women's organization in the nation. Besides fighting the liquor industry, the WCTU worked on reform in prostitution, child labor, public health, sanitation and war. As if to square off with the world's largest beer maker, the WCTU met at least twice in St. Louis—in 1885 and 1896. On November 14, 1896, nearly two thousand delegates and visitors came to the city for the twenty-third annual convention. The *New York Times* reported that the meeting opened at 8:00 a.m. with a Chautauqua cheer, the Crusade psalm and a hymn, "Give to the Wind Thy Fears."

President Frances Willard, the daughter of a minister, spoke first. Portraits of Willard show a handsome woman wearing dark, disciplined clothing—neat pleats, pressed laces and black brocade. Willard looked businesslike and determined behind a pair of scholarly glasses. Indeed, before serving nineteen years as president of the WCTU, she had been president of a women's college in Evanston, Illinois. Willard believed in women's moral superiority over men. She felt that one mission of the

WCTU was to bring men to the level of women. She introduced the "White Life for Two" program, which urged a couple to enter a lust-free, alcohol-free, tobacco-free marriage. Following this prescription, a man could aspire to a woman's moral plane.

Besides temperance, Willard believed in "a living wage; in an eight-hour day; in courts of conciliation and arbitration; in justice as opposed to greed in gain; in Peace on Earth and Good-Will to Men." The *New York Times* reported that Willard's speech to the convention made reference to the widely held suspicion that suffrage had been defeated in California by the liquor league. At the same meeting, the group agreed to work on the problems of gambling, to continue its efforts to find work and housing for immigrants and to remove the saloon from Ellis Island.

Two years after this meeting, the U.S. Brewers held another meeting and this time attacked the idea of votes for women openly by adopting a formal anti-suffrage motion. Years later, the women proved that the Brewers had financed anti-suffrage activities when one member testified in a 1919 Senate investigation, "We have defeated woman's suffrage at three different times." Catt and Shuler documented many instances when brewery organizations raised money for anti-suffrage causes.

In Missouri, matters were complicated by the payments the brewers made to the government. In 1883, the Downing Law of Missouri created a license system that charged saloons from $550 to $1,000, bringing significant income to both the state and the cities. The tie to government finances helped the brewers, but prohibition sentiment was still growing. By 1901, the national WCTU membership had climbed to 158,477, and it added 100,000 during each of the next two decades. When Missouri lawmakers got serious about passing a statewide prohibition amendment like the one in Kansas, St. Louis business was quick to organize against it. In one day, committees of the Business Men's League, Merchants' Exchange, Missouri Manufacturers' Association and several banks and trust companies met to call attention to their issue. The *New York Times* reported that if prohibition passed in Missouri, twenty thousand brewery workers would be unemployed and millions of dollars of investments lost to the state.

Even Phoebe Couzins succumbed to the power of the money of the U.S. Brewers when her success as a women's rights speaker did not translate into financial success. About 1905, she returned to St. Louis. Poverty-stricken, she agreed to work for the brewers against prohibition. She was not treated

fairly, however, and she eventually wrote the governor asking for help in collecting what she was owed by the Busch family.

All the businesses in St. Louis had ties to the brewers, and all clubs had prosperous members dependent on the breweries. To complicate matters more, Christian groups used alcohol in celebrations and even as part of their rituals. To avoid offending these groups, the WCTU was challenged to keep its arguments intellectual without moralizing. Instead, WCTU leaders alternated between condemning alcoholism as a personal moral failing and arguing about loss of productivity, which made alcoholism an economic issue. Eventually, on the national level, the conservative moralists became associated with an eastern branch of the WCTU, while the economic argument was associated with the West. St. Louis, predictably, was torn between the two ideologies.

Unable to form a successful relationship with the WCTU, St. Louis women created schools, orphanages, hospitals and clubs to solve city problems without offending the brewers and the political machine. The black community was as active as the white, forming clubs associated with church groups and schools. In 1877, black parents formed the Colored Education Council to convince the board of education to certify black teachers for their schools. By 1900, when they formed the statewide Missouri Association of Colored Women's Clubs, seven clubs came together. Four years later, there were twenty-four clubs in a citywide association, and they hosted a national convention during the 1904 Louisiana Exposition.

Probably the most prestigious club to spring from St. Louis society was the Wednesday Club, founded as a poetry study group, the Shelley Club, in 1889. Meeting in the home of Cordelia Sterling, wife of a brick manufacturer, the founders included Ella Barstow, wife of a director of the Mercantile Library and vice-president of the St. Louis public schools; Eva Perry Moore, graduate of Vassar College; and Amelia Fruchte, a Central High School literature teacher. Eleven of the twenty-seven founding members were single women, mostly schoolteachers living in the affluent West End and relatives of successful businessmen. The same month that the Wednesday Club was organized, a meeting in New York City brought together ninety-six clubs to form the General Federation of Women's Clubs, which the Wednesday Club joined. For the first few years it met in members' homes and then moved to the WCA building at Grand and Franklin, and in 1908 it built its own building at Taylor Avenue and Westminster Place in the Central West End.

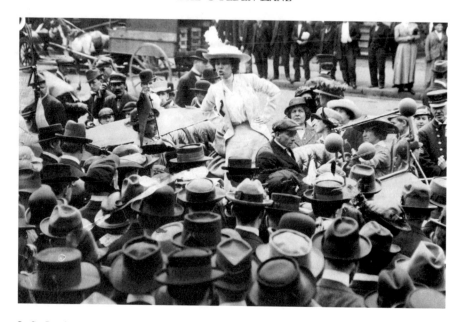

In St. Louis, Kate Richards O'Hare berated a crowd of men on National Women's Suffrage Day, May 2, 1914. *Photograph by the* St. Louis Times, *1914. Missouri History Museum, St. Louis.*

The Wednesday Club created kindergartens, built playgrounds, helped clear the polluted air and established parks. As much as it accomplished, it is important to note that the Wednesday Club also provided a space for discussion as well as direct action. And perhaps to make activist issues more familiar to the membership, the subjects were grouped under Municipal Housekeeping or Practical Work. With husbands who owned businesses that created some of the problems, club members were wary of antagonizing their own members. Instead, they invited speakers that could teach new points of view. Even the fiery socialist speaker Kate Richards O'Hare, living in St. Louis to work at the *National Rip-Saw*, was welcome to speak at a Wednesday Club meeting about the appalling conditions for women and children in the factories.

The club movement spurred a generation of Progressive-era volunteers, and more than one entrepreneur took note of the opportunity to further his own business. One important character in the story of clubs and the rising middle class is publisher Edward Gardner Lewis, founder of University City. By 1900, St. Louis was a center for publishing, with at least thirty newspapers and magazines catering to various segments of society, including

publications written in German, Polish and Italian. Lewis's publishing empire became successful from issuing magazines for women. In 1903, he purchased eighty-five acres and moved his business from downtown to the end of the streetcar line, where he created a development on the northwest edge of Washington University.

Just as University City was incorporated, with Lewis elected as mayor, postmaster Frank Wyman denied second-class mailing privileges for Lewis's *Woman's Magazine* and *Woman's Farm Journal* because of the large amount of advertising they carried. In the battle to regain the lower rate, Lewis lost many subscribers, so he tried a new marketing strategy. If a woman sold fifty-two dollars' worth of subscriptions, she would become a member of Lewis's American Woman's League. As the league grew, Lewis promised, the commissions of the sellers would go into a fund to provide education, money for their organizations and income for their old age.

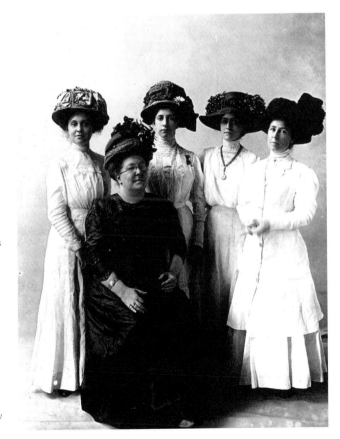

Members of the American Woman's League posed for a portrait in about 1909. Although Lewis had commendable goals for the league, the finances never worked out, and the league evolved into the American Woman's Republic, which helped women understand government, in preparation for the day they would vote. *Archives of the University City Public Library.*

An estimated seven hundred chapters were formed, but the league struggled financially. And the question of suffrage fragmented the membership, so in 1911, Lewis founded a second organization, the American Woman's Republic. A member of the republic paid dues that went into a fund to prepare women for leadership as voters. By 1912, the American Woman's Republic had completely replaced the failing league, and league chapters became chapters of the republic.

The republic held a convention in June 1912 and ratified a declaration of equal rights and a constitution, which was signed by more than four hundred members. Its capital was in University City, and it planned to convert one of the publishing buildings into a Supreme Court, senate and House of Representatives. As World War I began tearing apart Europe, the republic aligned itself with peace organizations and sent a delegation to the Peace Conference in Budapest.

In 1913, Lewis won his case against the post office. By this time, he had lost interest in University City, moving on to build an agrarian community in Atascadero, California, where he decided to live permanently. The American Woman's Republic stayed active, with its capital in University City, until 1916.

5

The Board of Lady Managers

We have been somewhat in the dark as to what we could and might do to contribute to the success of this great exposition, and we thought perhaps if we came and talked to you gentlemen upon the ground that you could throw us a little light.
—*Mrs. Mary Phelps Montgomery to the Louisiana Exposition's executive committee, 1902.*

The industrial era delivered on its promise to make life easy for those families lucky enough to have a fully employed and educated breadwinner. No further proof of the superiority of the age was needed than a look at the growing middle class. To celebrate how far the United States had come, two important international expositions were planned in the Midwest.

The Columbian Exposition in Chicago opened in 1893 with a weeklong Congress of Women, attended by about 150,000 women from twenty-seven countries and chaired by Bertha Honore (Mrs. Potter) Palmer, a wealthy Chicago socialite. A Board of Lady Managers, which included Mrs. Palmer and Phoebe Couzins, had been appointed to oversee special interests of women, the first time such a panel had been given power to work on an event of national, even international, stature. Couzins and Palmer had major disagreements, however. Couzins lost her position, and even though

the lady managers took their jobs seriously, the exposition turned out to be unimportant in the suffrage struggle, despite the fact that women's issues were explored in depth at the congress.

Eleven years later, the Louisiana Purchase Exposition was twice as big as the 1893 Columbian Exposition. The grounds covered twelve hundred acres and boasted more than fifteen hundred buildings, mostly temporary and constructed of plaster. Hundreds of Missourians spent the summer working at the Louisiana Purchase Exposition, where an estimated twenty million visitors came from all over the world.

As in the Columbian Exposition, the Louisiana Purchase Exposition celebrated progress and the superiority of civilized American life, including domestic life. St. Louis women looked forward to claiming a role in their fair, but it was hard to figure out just what that role would be. In 1901, a Special Act of Congress provided for the exposition and ordered that the National Commission of the Louisiana Purchase Exposition be "authorized to appoint a Board of Lady Managers of such number and to perform such duties as may be prescribed by said Commission, subject, however, to the approval of said Company." The only suggested duty was to "appoint one member of all committees authorized to award prizes for such exhibits as may have been produced in whole or in part by female labor." The Board of Lady Managers requested a meeting with the exposition's executive committee. Mrs. Mary Phelps Montgomery spoke:

> *We, of course, want to work in harmony with everything that has already been outlined, and we feel that we are a very weak body, but we want to add our efforts…We feel that women of this country have become a very great factor, but we also feel that the time has passed when we are to have a separate exhibit of what women can do, and we thought perhaps in some way we might be able to work in unison with the executive committee and the various other committees of the exposition.*

The executive committee suggested putting women in charge of care for women who attended the exposition, focusing on women's organizations or setting aside special days for women. Some of these possibilities had been taken care of already, and the executive committee had even arranged convention halls in St. Louis for women's meetings to be held without a fee. They asked that the lady managers send word to women's organizations to

bring their annual meetings to the fair. By now, there were dozens of women's organizations—professional, social and service clubs—ranging from the International Congress of Nurses of New York City to the Daughters of Liberty from Philadelphia to the PRO Sisterhood Supreme of St. Louis to the powerful WCTU.

There had been controversy at Chicago's Exposition about belly dancers on the Midway, so the lady managers asked that immoral dances be specifically excluded from the event and were assured that the executive committee had regulated concessions so it would be "impossible to present any amusement that can be classed as indecent or improper." It is possible that this regulation was put in place at the request of the WCTU. At the 1903 national convention in Cincinnati, WCTU members had requested the right to judge the decency of any attractions within a mile of the exposition.

Next, the lady managers requested that a committee of women be sent abroad to learn about women throughout the world. A committee of three was suggested: one from the East, one from the West and one from the Midwest. The chairman of the exposition agreed to consider the idea, but it was not funded. Meeting two months later, two women from the group—Appoline (Mrs. James L.) Blair, chairman; and Mary Margaretta Fryer (Mrs. Daniel) Manning—agreed to spend January 1903 in Washington, D.C., and acquaint themselves with the work of women in all parts of the world.

The women were beginning to see the complexity of the exposition management, with hundreds of committees and procedures for getting exhibits on the grounds. They asked Mr. Frederick J.V. Skiff, director of exhibits, how women would be presented in the exhibits, and he replied:

We are not working women's exhibits up any more than men's. It takes care of itself. We do not especially promote, except in this way: An officer of a department, if he understands his work, is given a classification. That is his bible. He makes up his mind what is possible to do in the way of an exhibit...For instance, in education, deaf, dumb, and blind; charity, philanthropy, and education of mind; conveyance of thought; social economy, the model city; machinery, that class of machinery that is most ingenious; electricity, electric therapeutics, electricmagnetism; transportation, aeronautics, Santos Dumont, etc.; forestry, fish culture, etc. They can add, and on broad lines develop, the highest type of the condition of the times.

In response, the lady managers set some goals. As mandated by Congress, they would select one member of each prize committee for exhibits with a female component and compile a list of all such exhibits. But they also resolved "to take part in the ceremonies connected with the dedication of the buildings of the exposition, and in official functions in which women may be invited to participate, and in any other functions, upon the request of the company and Commission."

The women also requested official status as advisors and offered in return to help recruit exhibits and visits from organizations. They offered to collect statistics about women's work for publication. Through publication, the work of women would receive official recognition. Perhaps the project closest to every woman's heart was to build a space on the grounds "for the relief of women and children who may be found in need of aid, comfort, or special protection." To staff this space, at least three women from the board were on the grounds at all times during the exposition, which was open from April 30 to December 1, 1904.

The Final Report of the Louisiana Exposition, 1906 documents the accomplishments of each building and department of the fair. As hostesses, the lady managers found money for space that included "a great banqueting hall, spacious drawing-rooms, handsome salons, comfortable resting places and cozy tea-rooms." They acquired fine furniture (including two pianos, one Steinway and one Chickering), silver from Tiffany and Gorham, and the world's best china from European manufacturers. The companies, swayed by the social connections of the lady managers, knew their products would be seen by dignitaries from all over the world.

The women, knowing they would be judged harshly if they lost money, took fiscal responsibility seriously. The Model Playground and Day Nursery, for example, charged twenty-five cents a day to entertain, educate, feed and care for children of fair employees. The playground also became headquarters for lost children, although there was no budget for this.

The lady managers found female judges for exhibits in art, food, education, agriculture, manufacturing, ethnography and social economy. Jane Addams served as a juror in social economy, having spent years in Chicago working for immigrant rights, women's suffrage and peace. Addams is still considered the world's first social worker and was especially sensitive to the impact of tradition and family on health and happiness. As a juror in "Housing of the Working Classes," Addams wrote:

The report for the Model Playground states that 7,350 children aged from two weeks to fourteen years were cared for in the eight months of the fair. Besides the children of employees and exhibitors, 1,166 lost children were brought to the playground. Receiving lost children, the women came up with a system of tagging each one and then helping them find playmates while they waited for their parents. *Missouri History Museum, St. Louis.*

From the nature of the exhibits in this department it is difficult to divide the work of women from that of men, for, although the erection of dwellings by public authorities, as in London, was naturally done through men who were members of the London County Council, and while the model dwellings [were] erected by large employers…the earliest efforts for amelioration in housing conditions, and in many cases the initiatory measures for improved dwellings, have been undertaken by women.

Improvements in housing conditions are so closely connected with the rate of mortality among little children, with the chances for decency and right living among young girls, with the higher standards and opportunities for housewives, that it has naturally attracted the help of women from the beginning of the crowded tenement conditions which unhappily prevail in every modern city.

There were five grand prizes for general achievements, and one was earned by a woman—Miss Octavia Hill from England. There were other medals awarded to women for achievements in housing.

To sum up the gains that women made at the Louisiana Purchase Exposition, beginning with the Special Act of Congress, the exposition honored women's places in society. Women were made to feel welcome and safe at the fair, and their contributions as both homemakers and workers were noted. One might think that this attention would immediately reignite the St. Louis suffrage movement, but this was not the case. Suffrage work would lie dormant until a new generation came along—a generation that would turn society upside down.

6
Mrs. Richardson,
Mrs. Usher

Two years ago, on good St. Valentine's Day, two new and struggling societies, the St. Louis Equal Suffrage League, then one year old, and the tiny Webster Groves League, of only a few week's age, met at the Cabanne Branch Library, and formed themselves into a State Association—truly an infant body—burdened like a royal child with a page full of names... powerless as such a child, but, happily like it also in its splendid potentialities, some of which are now beginning to realize.
—Cora Boyd, report to the biennial meeting of the Equal Suffrage Association, April 4, 1913

After the fair closed, there was a lull in St. Louis suffrage work. For poor women, political work was nearly impossible at any time. For the rising middle class, however, the lull was partly due to the intensity of the years surrounding the Louisiana Purchase Exposition. Areas around Forest Park had suddenly developed into streetcar suburbs, with their own shopping and cultural centers. Lucky and well-connected women were establishing new households there and adjusting to their new status as social leaders. Other women who may have been interested in suffrage were exhausted or felt they needed to make up lost time with their families. One mother-daughter team—Florence Wyman Richardson and Florence Richardson Usher— took the call.

Florence Wyman was the sister of postmaster Frank Wyman. She was born in St. Louis before the Civil War and married James Richardson in 1878. She was a graduate of the Mary Institute and the mother of six children. Her interests ranged from music (she played piano and organ) to trade union issues to lecturing and writing on theosophical studies. Her daughter and namesake, Florence Richardson, was born in 1889.

While the stories of many of the young suffrage leaders are now lost, we know about Florence Richardson because she followed the suffrage movement and collected clippings and pictures of the suffrage leaders in the United States and England. Florence's three scrapbooks are available on microfilm.

For young Florence, a debutante and maid of the prestigious Veiled Prophet organization, the suffrage movement was exciting and romantic, peopled with glamorous stars. Like other young women in the rising middle class, she was interested in fashion. Her generation brought a new twist to the suffrage movement, something we might call Gilded Age glamour. Her formal portraits, and those of her friends, were reproduced in the newspapers. These are young beauties posing to show off their fashionable outfits and sense of style.

The earliest clippings, pasted carefully into the scrapbook, include articles about the Women's Christian Temperance Union storming the capitol in Jefferson City in 1908 and clippings about women selected for jobs that could have been taken by men—a woman selected as librarian at Princeton University, a woman hired as a journalist in Germany, Mrs. C.B. Shelton elected governor of Oregon. There is an entire British magazine headlined: "Votes for Women: Special Deputation Number, June 29, 1909."

The first two pages of the first scrapbook, however, are Florence's own writing, telling the story of her first involvement with suffrage. These words are typed on stationery, the old formal kind, perhaps for a speech or a news article. The austere heading, "5739 Cates Avenue, St. Louis, MO," was her home after marriage on the same street as her mother. So these two pages were written later in life, a reminiscence of the story that began when she was a girl of eighteen:

> *In 1907 and 1908, becoming convinced that I must become allied with the work to enfranchise women, and not knowing anyone here who was interested, nor that there was such a thing as a national association, I wrote*

Mrs. Richardson, Mrs. Usher

letters of inquiry from time to time to women prominent in the women's club movements, their names being suggested from newspaper reports.

After a year of writing, Florence got in touch with Sara Platt Decker, who told her about the National American Woman Suffrage Association (NAWSA) and put her in touch with Miss Laura Gregg, another young woman who was working in Illinois. Gregg stopped by to meet with Florence, probably in the spring of 1909.

At the time, NAWSA was trying to collect names to petition Congress for a constitutional amendment, dubbed the "Susan B. Anthony amendment." It approached the work in an organized manner. "A strong pull, a long pull and a pull all together will bring the result we desire," read the instructions for signature collection, signed by NAWSA president Carrie Chapman Catt and circulated to workers. The petition campaign was well organized, and instructions were detailed. The organization's first step was to find influential persons who "will give courage to the timid." There would be a house-to-house canvass, if possible, in cities and small towns. There would be campaigns in the Grange and Farmers Alliance in the country. Men and women were to sign the same petitions, to signify that this effort was not only backed by women.

Florence agreed to gather names. She wrote to the West End Business Men's League, which had endorsed women's voting in local elections as one of twenty-four planks for a municipal campaign. The endorsement was partial and confusing: The league would allow women to vote on city issues if 25 percent of the taxpaying city-resident females petitioned for it. The city district, it said, had more businesswomen, so rural districts were excluded.

Charles F. Ziebold, a member of the board of directors of the businessmen's league, answered Florence's letter, and she pasted his answer in her scrapbook. He explained that they had endorsed businesswomen voting in municipal elections "because limiting the privilege to tax payers will exclude the irresponsible, and general riff-raff, element of the female population, which element, having the suffrage under the present conditions, would merely be used by unprincipled and unscrupulous politicians in the furtherance of their well-known unworthy practices." The league did not endorse further suffrage. Ziebold confessed, "We were impelled to the adoption of our Declaration because it is in line with the trend of the present times. All the States are broadening the rights and responsibilities of women under their Married Women's Acts."

Undiscouraged by his reply, Florence looked for other groups to circulate petitions. She found supporters among the women of the Wednesday Club. At a meeting in March 1910 at the Cabanne Branch Library, she spoke about the cause. The *St. Louis Post-Dispatch* (oblivious to nearly fifty years of women's history) called this the "first suffragette meeting ever held in St. Louis." The reporter noted that, while young Florence's remarks defended the militant actions of the English suffragettes and called for "kicking up a row," the most memorable part of her presentation was "the first chanticleer hat that has made its appearance in St. Louis" and the young men who "thought the discussion funny." Fortunately, the young men in this instance left peacefully.

Other speakers at that meeting included the fashionable Lulu MacClure Clark, who said, "There are only two occasions when the help of women is called for…The first of these is when the men want the rats killed, and the second is when they want a million population." A few years after this meeting, Clark became an early advocate for women's rights to birth control. Other participants at the meeting included Mrs. William Ward; Miss Hildegard Hallen, a stenographer; and Bertha Rombauer (sister of Missouri's Speaker of the House, Edgar Rombauer).

After the success of the meeting, Florence began work to bring Mrs. Emmeline Pankhurst, a leading British speaker on suffrage, to St. Louis. This was the age of touring entertainment. Arriving by ship in New York, speakers, opera singers and even entire orchestras would be dispatched on a circuit to the West, touring for a couple of months in northern cities on the way out and southern ones on the way back to New York. Their presentations were sponsored by clubs along the way, enhancing each sponsor's reputation and bringing entertainment and serious discussion to the hinterlands. Pankhurst visited the United States four times between 1909 and 1915, and her daughters Sylvia and Cristabel also made tours. There is a promotional brochure in the Usher scrapbook for Pankhurst: "The World Famed Leader of the English Suffragettes, under management of the J.B. Pond Lyceum Bureau, 23rd St. and Fourth Avenue, New York. Metropolitan Life Building."

Pankhurst would speak on "The Militant Methods of the English Suffragettes," "The Meaning of the Woman's Movement in England," "Why Women in England go to Prison for the Vote" and "Why Women Want to Vote and How to Win It." She would be in the United States for five weeks, and groups could apply for her to come to their community. The

brochure continued: "Mrs. Pankhurst is a powerful debater and speaker, and at the close of the lectures will be prepared to answer questions that may be put to her on the suffragette Movement. She will arrive in New York on the 18th of October…early application for terms and dates is necessary."

The first Pankhurst visit was postponed, but another British speaker, Ethel Arnold, came to St. Louis in April 1910. Arnold decried the violence of the militants, saying, "Whatever you do in your work for suffrage here in America, don't put on the red cap. That is what the women in England have done, and the movement has been set back just so much. It was a big mistake." Another British speaker, Mrs. Philip Snowden, wife of the British Parliament member, gave her personal views at another Wednesday Club meeting. At about this time, St. Louis women began to consider the distinction between those who embraced violence—suffragettes—and those who could not—suffragists.

The unwavering young Florence continued to promote a Pankhurst visit. A meeting was called at her mother's home on Cates Avenue with an invitation proclaiming, "The time now seems ripe for action." Just a few months later, on June 9, 1910, Florence was married to Roland Greene Usher, a professor at Washington University who would soon become head of the History Department. Usher was from Massachusetts, a state that had granted property rights to women in 1854. He was a suffragist in his own right and a pacifist.

Florence Usher was successful in building support for the Pankhurst visit and recruited the Wednesday Club, along with her mother, who was acting as chair at the time. She was now a married woman, so young Florence lost some of her allure for the press, and Lulu MacClure Clark became the new headliner. "Society Girl Supports Woman Suffrage Cause," headlined the *Star* on October 30, 1910.

The time was right for the issue to move forward. In the state of California, another referendum was grabbing headlines with parades, billboards and pageants. News even reached Missouri. One cliffhanger precinct was in San Francisco, and on October 11, 1911, the *St. Louis Globe-Democrat* reported, "Woman suffrage appears beaten…San Francisco reform lost…Many voters were turned against the women by the spectacle they afforded in their eagerness to win the men to their cause." The next day the newspaper had to recant with the headline, "Victory for Suffragists" in San Francisco.

On February 14, 1911, the first meeting of a new suffrage organization— the Missouri Equal Suffrage Association—was held in St. Louis at the Cabanne Branch Library. This association would spawn a variety of leagues

The board of the Equal Suffrage Association meets in its headquarters. Mrs. Richardson, Mrs. Usher, Mrs. Boyd, Miss Taussig, Mrs. Lewis, Mrs. Harris, Mrs. Bernice Morrison-Fuller, Mrs. Tittmann and Mrs. Crunden are probably here, but there is no record to tell for sure. *Missouri History Museum, St. Louis.*

and committees around the state. Florence Usher put a copy of the minutes in her scrapbook. The meeting was called to order by Cora (Mrs. W.W.) Boyd, and Mrs. Richardson and Mrs. Usher moved things forward. Florence Richardson was elected chairman of the meeting, and Florence Usher nominated Miss Charlotte Taussig as secretary of the meeting. A bylaws committee—Florence Atkinson Lewis (Mrs. Robert) and Mrs. Charles Harris—presented proposed bylaws. The first contributions were ten dollars from Mrs. Bernice Morrison-Fuller, ten dollars from Mrs. Boyd, five dollars from Emma Roe (Mrs. Harold H.) Tittmann and five dollars from Elizabeth Chittenden (Mrs. Frank P.) Crunden.

The new club joined the National American Women's Suffrage Association and sent it ten cents per person. Cora Boyd, corresponding secretary from February 1911 to May 1912, wrote her memories about the early days of the organization:

Mrs. Richardson, Mrs. Usher

So that when we went to print our constitution and by-laws and to buy stationery on which to print our grand title and list of officers, and to proclaim to the World that we were members of the great National American [Women's] Suffrage Association, we began to go into our own pockets and beg from our friends. But what returns from that stationery. It was so imposing that it imposed upon us. And we boldly wrote under its wonderfully impressive letter head to great persons and grand associations whom we never would have dared to approach on plain paper. On this magic paper we wrote to a long list of Missouri Editors begging them to put a column of suffrage news into their papers weekly, and they being duly impressed promptly acceded to our request—so that twenty six papers have done this work for us for over a year. In passing I must tell you of the editor who declined to do this, but gave in explanation that he had a suffragette on his staff, and that she gave them all the suffrage "dope" which they could use...

[W]e saw an editorial ridiculing the idea of "strike of wives" and we wrote and told them that the idea was not new, but as old as the Greeks, and cited Aristophanes and his Lysistrata in proof, incidentally showing that in that drama, the new woman was portrayed as striking to save her sons and her land from the horrors of war—and that successfully too.

There were suffrage clubs forming in Warrensburg and Kansas City, affiliating with the St. Louis group, but MESA had no luck starting chapters in smaller Missouri towns. "Our President offered to go, but each one made excuse 'the time has not come,' or 'it would never do in our city.' The fact of the matter was that even a year ago Missouri was not ready to discuss much less embrace suffrage." By May, however, the Kansas City League could report that it had seventy-five members and twenty-five "promised." Florence Usher had also spoken to a black women's club, urging it to work on suffrage.

When Emmeline Pankhurst finally came to St. Louis, the event was a social success. "Dazzling Audience Hears Pankhurst, English Suffragette, as She Urged Militancy," blared the *St. Louis Republic* headlines on November 4, 1911. "St. Louis society, at least a great part of it, outdid itself and overflowed the Odeon in evening gowns and 'spike-tails' 2000 strong last night, when Mrs. Emmeline Pankhurst conducted a 'political meeting,' the like of which was never held in St. Louis before."

The men in their elegant "spike-tails" were something new to the movement, perhaps inspired when the newspapers reported that William

Faversham, a dashing theater producer and husband of popular actress Julie Opp, garnered publicity as the "suffragist husband." Florence Usher kept the clipping, which reported "the first time the tears of a man have been recorded as having caused a woman to desire to vote." On a trip to England, apparently, Faversham had been very moved by a suffrage parade in England. Julie Opp took a while to join her enlightened spouse, but eventually, she said, "I awoke to a realization of the truth and the necessity of women's mind expanding and taking an active part in the routine of life. Now I am a Suffragist and I have a Suffragist husband and two Suffragist baby sons and it is my intention to whole-heartedly support the demand."

For the third scrapbook in her collection, beginning in 1912, Florence pasted articles into an invoice book. The names of male supporters of women's suffrage were now appearing regularly in the headlines. On January 4, 1912, there was a men's symposium on women's suffrage. This was an innovation, with men making the arrangements and doing the speaking, but women were allowed to attend and listen in. The fearless journalist William Marion Reedy—publisher of *Reedy's Mirror*, a popular national publication based in St. Louis—attended the meeting. Reedy was famous for saying everything and anything he wanted to say, and he gave a forum to young writers, many of them women. He was an ardent supporter of women's rights. Among the authors first published by Reedy were Sara Teasdale and Fannie Hurst.

Pankhurst planned a return through St. Louis. But St. Louisans, while embracing the principle of suffrage, rejected the violent strategies of the English suffragettes. Suffrage violence seemed too close for comfort to prohibition violence, and the bar-smashing campaigns had been in the news just a decade earlier.

In the Usher household, the looming Pankhurst visit caused tension. In January 1912, Florence Richardson was serving as president of the St. Louis Equal Suffrage League and had promised Emmeline Pankhurst an engagement. At first, Roland Usher agreed to introduce Pankhurst, but he announced a few days before her appearance that he had changed his mind. Speaking at the Wednesday Club, he said, "I am not in favor of window smashing and assaults on people as a means of getting anything. I am in favor of an educational campaign that should give woman the right to vote whenever the community as a whole is convinced she ought to have it...violent measures can only prevent the object the suffragists wish to gain." It was a courageous stand, considering the positions of his wife and mother-in-law.

WANT LIQUOR IN MISSOURI.

Business Men Begin Agitation Against the Prohibition Amendment.

ST. LOUIS, Mo., April 16.—Concentrated opposition by organized commercial, financial, and manufacturing interests of St. Louis to a State-wide prohibition amendment began in earnest to-day when four meetings of protest were held. Committees were appointed to urge upon members of the State Senate the danger to local interests, and were instructed to call attention to the fact that 20,000 brewery workers would be thrown out of employment in this city alone, and that millions of dollars of invested capital would be lost to the State.

The organizations which met to-day were: Executive Committee of the Business Men's League, Board of Directors of the Merchants' Exchange, Board of Directors of the Missouri Manufacturers' Association, and representatives of banks and trust companies.

From the New York Times.

A few months later, perhaps to support Roland Usher's words, the City Club hosted a Saturday afternoon visit from pacifist Jane Addams, who told members, "The English way is not ours." Indeed, on February 20, 1913, just a year after Pankhurst's visit to St. Louis, the movement in Great Britain became extremely violent, and in Cardiff, Wales, a Pankhurst meeting ended with a mob that blew up the home of the Chancellor of the Exchequer. "The authorities need not look for the women who actually did it," Emmeline Pankhurst told the crowd. "I personally accept responsibility for it."

Eschewing violence, American suffragists in some states were having success gaining the franchise. The State of Washington gave full voting

rights in 1910; California gave full rights in 1911; and in 1912, women in Alaska Territory, Oregon, Arizona and Kansas gained the vote. For the first time, presidential candidates included women when they argued their points for the 1912 election. Mrs. Boyd's memoir continued:

> *So when the cables flashed the successive dispatches across the sea...and this in turn was followed by the startling news of three more states having given women the vote, the hands of my suffrage clock leaped ahead, Mr. Reedy's famous saying, "it is sex o' Clock" became a vivid reality and I said, and thanked God for it—"The Missouri Equal Suffrage Association will never have to struggle again for a hearing."*

In the Richardson and Usher households, the suffrage issue was dropped as Roland G. Usher's career took a turn to national prominence. The war in Europe was heating up. Florence Usher's career of service continued, and to the end of her life, she campaigned for civil rights. Many of Roland Usher's books and articles have been preserved on websites devoted to the world wars. But as for Florence's scrapbooks, there are a few more clippings, and then Florence Usher stopped collecting. St. Louis had decided not to study violence, but there was obvious need for a new strategy. The Missouri suffragists would turn their attention to the national scene.

7

Parades

We had gone but a short distance when the crowd started closing up toward the line of the parade, and men blockaded a place in the street a short distance ahead. One of the suffragist officers came rushing back to us and told us to march on ahead and lead; that it would be necessary for the band to open the way proved true. We were not molested in the least and although the march was slow on account of the crowds, no one offered to stand in our way down the avenue.
—*Maryville bandleader Alma Nash, 1913, quoted in* Show Me Missouri Women, *edited by Mary K. Dains (Thomas Jefferson University Press, 1989)*

While Florence and Roland Usher were working out their differences in St. Louis, the new generation of women on the East Coast was getting impatient. Like the Missourians, these women had education, leadership, organizations and proof that their participation was crucial to society. But also like women in Missouri, the educated East Coast women were ignored. Clearly, they needed a new strategy.

The earliest suffrage marches were led by the American Suffragettes. This group was formed by Bettina Borrman Wells in New York and embraced civil disobedience, conducting marches and meetings without permits. On February 16, 1908, Wells led twenty-three women through the streets of New

York City to Madison Square. The leading Missouri suffragists, members of the St. Louis Wednesday Club and wives of civic leaders all over the state, read about the New Yorkers in the press, but they could not adopt civil disobedience. For Missouri women, as we have seen, there was enough risk in simply meeting and advocating for themselves. They needed to be visible, worthy of the vote and strong. Most of all, they needed to be respectable.

Harriot Stanton Blatch understood this well. She was the daughter of Elizabeth Cady Stanton, who had first asked to vote back in 1868. Blatch had graduated from Vassar, traveled and written extensively on women's work for suffrage. Then for twenty years, she lived in England, where the suffragettes were active. Returning to the United States in 1908, she became an activist for trade unions and women. Finding the U.S. organizations tame and ineffective, she launched the Equality League of Self-Supporting Women. The league reenergized the suffrage movement, and Blatch's parades put the work into high gear. As she explained to the *New York Tribune*, "Men and women are moved by seeing marching groups of people and by hearing music far more than by listening to the most careful argument." A parade was a way to take the arguments into public spaces and show solidarity—and doing it with a brass band.

Until the suffrage parades, marching in groups to claim their rights had been a tradition of men, mostly laborers or immigrants. Nothing, it seemed, illustrated the power of democracy and civil rights for a marginalized group more than a parade. Laborers' parades forced them to craft messages to explain what was wrong and also garnered attention for their problems. Even though their high energy might disintegrate into bloody violence, the marches were a good publicity tool for those with no other access to the press. For women, the parade was a risky tactic because some public spaces were off-limits to women; if they went downtown at all, it was to shop and quickly return home. Marching exposed them to (at best) patronizing and (at worst) ridicule, disrespect and violence. In fact, one parade—before the inauguration of Woodrow Wilson in Washington, D.C.—threatened to become a violent mêlée until a women's marching band from Maryville, Missouri, saved the day.

Blatch and the new leaders called for peaceful, organized parades. Missouri women could wear sashes reading "Votes for Women" and respond to this call. They marched in their hometowns and traveled to join parades in urban areas. On May 21, 1910, a month after New York lawmakers

rejected a state suffrage bill, Blatch's first Equality League parade was held in Manhattan. Hundreds of women, mostly New Yorkers, participated. As Jennifer L. Borda wrote:

> *The floats…highlighted respectable images of women and their status as citizens worthy of the franchise…On the first float rode "the delicate lady of long ago" represented by a petite woman sitting in a sedan chair carried by four men. Small and helpless, she represented women's submission to the restrictions placed on her sex. The next float represented the "olden days in the home" featuring women cooking, spinning, and weaving. Designed to inform participants of women's unique contributions to society, the float also was a reminder that industries that were once domestic now had moved outside of the home…the story always ended with a dramatic statement on the modern woman, her power, and her presence.*

This first parade gave women a chance to be creative and to show their power, freedom and autonomy. Just the fact that they could take a day off, pay for passage to the parade site and meet with others proved how much they had accomplished. Beautiful and noisy, with bands, colorful banners, gilded wagons pulled by horses and beautiful costumes, parades made the marchers feel proud and unified. The parades also educated the marchers that some women could vote by including women representing voters from around the world, including China, Denmark, Sweden and the enfranchised states.

In Blatch's 1910 parade, women embroidered their arguments on banners carried as moving proclamations. Banners proclaimed, "New York State Denies the Vote to Idiots, Lunatics, Criminals, and Women," "Not Favor but Justice" and "Taxation without Representation Is Tyranny."

A year later, Blatch's parade linked suffrage with labor causes, especially emphasizing women in the workplace and professions. One of the marching units included sweatshop workers with a draped coffin, just months after the Triangle Shirtwaist Factory fire. Leading this parade were the glamorous socialites Inez Milholland and Sarah McPike and a large banner reading, "Forward out of error, Leave behind the night; Forward through the darkness, Forward into light." The *New York Times* noted that there was a large corps of "athletic girls" marching without hats and carrying tennis rackets and basketballs.

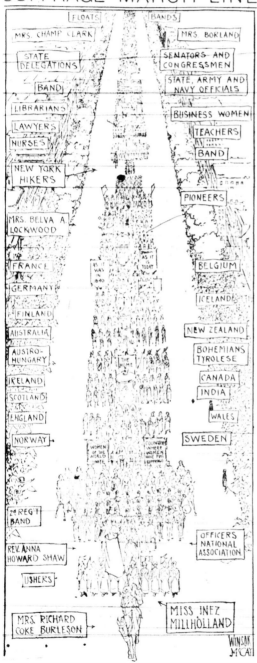

How Thousands of Women Parade To-day at Capital.

SUFFRAGE MARCH LINE

FLOATS · BANDS
MRS. CHAMP CLARK · MRS. BORLAND
STATE DELEGATIONS · SENATORS AND CONGRESSMEN
BAND · STATE, ARMY AND NAVY OFFICIALS
LIBRARIANS · BUSINESS WOMEN
LAWYERS · TEACHERS
NURSES · BAND
NEW YORK HIKERS · PIONEERS
MRS. BELVA A. LOCKWOOD
FRANCE · BELGIUM
GERMANY · ICELAND
FINLAND · NEW ZEALAND
AUSTRALIA · BOHEMIANS TYROLESE
AUSTRO-HUNGARY · CANADA
IRELAND · INDIA
SCOTLAND · WALES
ENGLAND · SWEDEN
NORWAY
24 REG'T BAND · OFFICERS NATIONAL ASSOCIATION
REV. ANNA HOWARD SHAW
USHERS
MRS. RICHARD COKE BURLESON · MISS INEZ MILLHOLLAND
WINSOR M'CAY

Watching a suffrage parade was seeing a world pageant pass on the street: Blocks of marchers represented women (as the *Globe-Democrat* reported) "in the field, the farm, the home, in patriotic service, in education, medicine, law, labor, government and other fields of endeavor." Banners carried appeals from businesses and the states and included marchers from states that had passed suffrage completely or in part. "Nearly all women marchers will be gaily uniformed," reported the *Globe-Democrat*, "and the floats and golden chariots that are to appear have been prepared with regard for the beautiful." *Library of Congress.*

Parades

The next year, a parade on Fifth Avenue, New York, included women as homemakers and mothers. Banners read: "We Prepare Children for the World. We Ask to Prepare the World for Our Children," "A People Learns to Vote by Voting" and "More Ballots, Less Bullets." This demonstration was to show the unity of women and highlight the growing social consciousness of women as a whole. Men and babies were included in that parade, and the *Post-Dispatch* reported, "Fifteen thousand women of nearly a dozen nations display growing power. Fifty ride in saddles. Gowned in white with yellow straw hats, hear twenty bands. Actresses, waitresses, nurses…hundreds of thousands of persons looked on from windows and balconies…There was no disorder."

The orderliness and respectability of the marchers were key to the success of the events, but each parade also added new features to make the women visible and demonstrate their worth as citizens. Speakers carried soapboxes and stopped on designated corners to argue their cause. This kept spectators engaged after the parade had passed. When the soapbox speeches concluded, spectators might follow to a rally, where the crowd heard speeches by Harriot Blatch, Dr. Anna Howard Shaw (NAWSA president) and Leonora O'Reilly (activist for women in trade unions). The demonstration gained the endorsement of the Progressive Party.

Another parade was planned for March 3, 1913. This one was to be in Washington, D.C., the day before the inauguration of Woodrow Wilson and was organized by Alice Paul, the "anemic suffragette," who fretted over spending more than thirty cents a day on her own food. Wilson had not signed on to the idea of universal suffrage, and this parade was planned to demonstrate the involvement of women in all aspects of American life. Sections of the parade comprised writers and authors, doctors and other professional women and homemakers. The parade drew so many people that when Wilson arrived at the train station for his own inauguration, it was practically empty.

This parade portrayed the history of the suffrage movement, with sections representing the worldwide movement's seventy-five years of struggle. One section proclaimed, "Man and woman make the state." At the time, Missouri women were busy with a petition drive at the state level, but a capable group made sure that Missouri was well-represented and raised money to build and send a float for the state's section. The float transmitted a dignified message of women's worth through the ages: "[It] consisted primarily of a bronze chariot and throne chair, which will be occupied by Mrs. George Gilhorn

[*sic*], president of the Missouri Equal Suffrage League…in Greek robes of appropriate color and will hold in each hand a torch spurting artificial fire." Genevieve Davis Bennett (Mrs. Champ) Clark had offered to meet the delegation and lend her support.

To raise excitement in Missouri's suffrage community to a fever pitch, the *Globe-Democrat* reported, "The Maryville Womens' Band of Maryville, MO., has been chosen to lead the big suffrage pageant which will march along Pennsylvania avenue to-morrow afternoon, rain or shine." The band would follow the glamorous Inez Milholland riding on a dramatic white horse and the NAWSA leaders, including Dr. Anna Shaw carrying a banner that proclaimed, "We Demand an Amendment to the Constitution of the United States Enfranchising the Women of the Country."

Fundraising had begun two months earlier when the *Maryville Democrat Forum* reported that the Missouri Ladies Military Band had been invited. The band needed to raise $1,250 for expenses, and the people of Maryville responded with $500 in donations. St. Louis kicked in $150. The *Globe-*

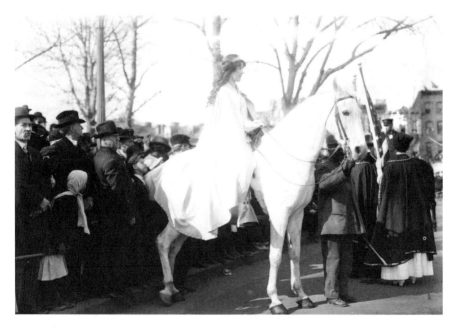

The *New York Times* reported, "Miss Millholland was an imposing figure in a white broadcloth Cossack suit and long white-kid boots. From her shoulders hung a pale-blue cloak, adorned with a golden maltese cross…Miss Millholland was by far the most picturesque figure in the parade." *Library of Congress.*

Democrat continued: "Mrs. Lafayette Ewing of St. Louis…designed the Missouri float and arranged for the painting of a banner to be carried ahead of the float by Dr. Avis Smith of Kansas City." Another source, a report of the St. Louis Equal Suffrage League, said that the float was designed by Miss Caroline Blackmann of St. Louis. This was probably correct, leaving Mrs. Ewing to be a fundraiser. The league also reported that the Missouri delegation was headed by Mrs. Clark, with the banner carried by Dr. Smith of Kansas City.

As we have seen, segregation plagued the suffrage community and, as a compromise with segregationists, Alice Paul announced that black women would march at the end of the parade, in their own contingent. Most did, providing a visible presence, but Ida B. Wells Barnett, a Chicago civil rights activist and journalist, left the block and disappeared into the crowd, moving ahead to join the Illinois contingent.

As it turned out, the twenty-two Maryville women were, in large part, responsible for the success of the march. Returning home, Nash told a reporter, "The part they took in the suffrage parade is not fully realized by them." They began, as planned, behind Inez Milholland and the NAWSA leaders, but as one of Nash's pupils said:

> *Just as the parade began, a crowd of resentful, unruly men up ahead refused to let the first unit pass. In desperation, Miss Nash signaled the downbeat…and music worked its magic. The crowd quieted; they listened while the Missouri Ladies Military Band played its entire repertoire, all the time surrounded by the mob. Just as the musicians ended their finale, the cavalry arrived from nearby Fort Myers, opened the way and the marchers completed their parade to the steps of Continental Hall.*

Maryville's Alma Nash was the daughter of a remarkable couple—a husband-and-wife medical team who performed surgeries together as doctor and nurse. Music was a big part of the family's life, and young Alma began study as a girl. She attended Maryville Institute and graduated with a degree in stringed instruments; she then studied in Denver, Colorado, and eventually played with a women's band in Atlantic City, New Jersey. In 1905, at age twenty-two, she opened a music school in Maryville, teaching banjo, mandolin and guitar, and at the same time played drums in the local theater.

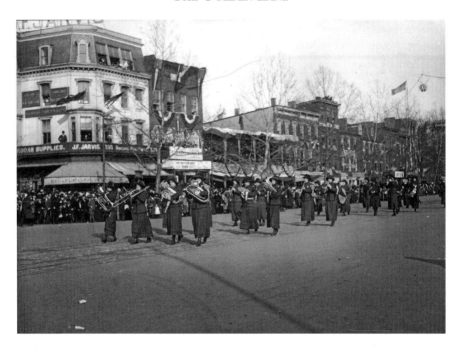

Because they were the only all-woman band in the parade, the newspapers excitedly covered the Maryville Band, and Dr. Anna Shaw met them at the station. After the parade, the band held together for two more years, until many members were lost to marriage. Alma Nash moved to Kansas City and continued her music career and teaching. *Library of Congress.*

When she organized the Missouri Ladies Military Band (with as many as thirty-two women at one point), invitations poured in from all over Missouri and from the states near Maryville—Iowa, Kansas and Nebraska. Many of the members were schoolteachers, so the travel and performances provided opportunities to see the sights out of Nodaway County. The women purchased snappy uniforms of navy blue jackets and white skirts and played for summer picnics and gatherings. After the march, they became so popular that they were paid for performances ($2.50 per woman, plus expenses) and had to turn down many invitations.

Besides providing education and fun, the parades gave women the chance to get together and discuss their issues. One newspaper reported that the Illinois delegation met to talk about the use of the title "Miss" as opposed to "Mrs." A vote was taken, and the women voted sixteen to four in favor of remaining "Miss" until the right man offered to make it "Mrs." Married women were not allowed to vote. The chair told them, "You are too prejudiced."

Parades

In other meetings, speakers took on weightier issues, such as "the burden of the white slave traffic, child labor and underpaid women workers in the sweat shops and factories of the larger cities of the country." Carrie Chapman Catt charged men with "responsibility for all the evils under which the women of to-day are suffering…if the 'protectors' would give women the vote, they would be their own protectors."

Two months later, on May 10, 1913, a parade in New York City drew 10,000 marchers—including 500 men—to Fifth Avenue. This was the largest parade of all and drew between 150,000 and 500,000 onlookers. A new feature was the addition of all-male reviewing stands, which attracted men to the cause. Seeing women as professionals persuaded men that women deserved and needed political power.

While the parades demonstrated peaceful unity, the national scene was surviving yet another split. Just months before the Maryville Band marched in Washington, D.C., Alice Paul and Lucy Burns founded the National Woman's Party (NWP) as part of NAWSA. The NWP hoped to demonstrate the power of four million women in western states that had already received the vote. Gradually, their work shifted from the state-by-state level to working for a federal amendment. Inspired by another visit from Emmeline Pankhurst, they demonstrated in front of the White House despite public disapproval. By December, they had been expelled from NAWSA, setting up a bitter rivalry.

In Missouri, new leadership was also emerging. This new group, rather than being more radical, made its mark by being genteel, good humored and very, very smart.

8

Emily Newell Blair

No young woman like me with the same repressed ego and urge for self-expression and attainment will be hampered by the Victorian concepts that hampered me...She does not have the same concessions to make to respectability, the same compromises between domesticity and marriage.
—*Emily Newell Blair, from* Bridging Two Eras, *edited by Virginia Jean Laas (University of Missouri Press, 1999)*

Emily Newell Blair of Carthage, Missouri, wrote that she was surprised by the part she played in the suffrage movement. "Why I got into the suffrage campaign I do not really know," she wrote in her autobiography. "Helen Guthrie Miller was, of course partly responsible; for no one, so far as I know, ever refused to do anything this patrician, urgent, charming suffrage leader asked her to."

The daughter of successful parents in Joplin, Emily was photographed many times in her life. In 1896, at age nineteen, she is very much the young lady in a white dress decorated with bows, holding a white fan with a corsage of roses on her shoulder. Her dark hair is pulled into a loose braid, and she gazes modestly away from the camera, three-quarters of her face visible. The dress has ruffles in every possible place—several on the sleeves, one on the hem, at the neck and bodice, as ruffled as Cinderella at the ball.

A few years later, in her wedding portrait, she is again all in ruffles. Her hair is up, and she looks at the camera, but there is only the slightest smile. In fact, in all the photographs, her expression seems to hold something back, as if the whole process of being dressed, posed and photographed was in itself baffling. Although she would become a successful woman, nothing in the portraits hints at self-confidence. This is true of all the portraits until one formal pose made late in life.

In her early portraits, her eyes are fixed on nothing in particular, and she does not smile. "What does the world want from me?" she seems to say. "How am I to react to this camera, this photographer, this studio, this curtain behind me?" At a time when suffragists were usually photographed in dark clothes, pressed and tidy, hair in tight braids and the camera sharply focused, Emily Blair is in slight disarray, as if she has just rushed away from something all-consuming, and seems always to be in soft focus. Whether photographed with her family or in her office, she is unsmiling and distant. Large, dark eyes

In her autobiography, Blair wrote about being torn between duties to her family and her desire for public life. Indeed, her feelings must have been echoed by thousands of women who found themselves speaking out for the vote, addressing envelopes, campaigning, raising money, teasing their husbands into going to meetings and, generally, working hard for something that seemed hopeless. *Photo from about 1920, courtesy Cheri Thompson, 1988 National History Day Media Project donated to Powers Museum, Carthage, Missouri.*

look out from her pretty face almost fearfully, and one wishes to have known her, heard her speak. Perhaps she was always engrossed in thought. Perhaps this is how a woman in her situation got by.

Even though society was changing rapidly, with women testing the boundaries between the two spheres, most wives were busy with families and friends, leaving little time to worry about issues outside their own lives. Like other women, Blair expected to live the same sort of life as her mother— "bear a family, run a house, and spend her husband's money." And, she wrote, she had played that role from the time of her wedding on Christmas Eve 1900 until she began her writing career.

She wrote that her marriage to Harry Blair was "the greatest stroke of luck I ever had." Harry, a court reporter, lived in Carthage. He became a lawyer, and Emily became a young housewife (admittedly extravagant), who learned to cook and entertain. She sewed clothes for friends and worked at embroidery. "Someone ought to write a book someday on the tasks restless women have invented to occupy their time," she wrote. Soon, she found herself following Harry's court cases and accompanying him to court.

Her interest in Harry's law career was more than wifely, however. Emily Blair was a writer—and an explorer, experimenter and campaigner. She would later become credited as the architect of the Golden Lane, organizer of the League of Women Voters and author of several books and countless articles. Unlike many suffragists, Blair worried that her public work interrupted her duties as wife and mother. Perhaps to put her career into the proper sphere, she claimed that her writing began when she became tired of articles by unhappy wives and responded with an article called "Letters of a Contented Wife."

Although she claimed that "Letters of a Contented Wife," published by *Cosmopolitan* in December 1910, was her first writing, Blair editor Virginia Laas found an earlier publication, "Our Cooperative Kitchen," published in *Woman's Home Companion* two months earlier. The story covered Blair's experimental dining room, created to provide family meals to members who couldn't afford servants but did not wish to cook all their own meals. The kitchen served its first meals on September 16, 1909, and survived until January 1, 1912. Twenty families ate at the cooperative kitchen, pooling their money to hire a cook, and the meals became a time for entertainment and conversation. At one dinner, Emily found herself pointing out that it seemed silly to elect county recorders, treasurers and collectors. "Why didn't

we elect one board, turn the county business over to it, and let it engage clerks to do the work?" she asked. The men replied that the idea was "infantile, impractical and silly." She concluded that "women were to be entertaining, not argumentative. I tried to conform to this requirement."

A regular guest at the kitchen was the town music teacher, Professor Calhoun. He led discussions, and Emily found herself participating and arguing for her ideas. The professor said she had a "man's mind," and she began to consider her point of view worthwhile. Later, she wrote that she had not heard Dr. Anna Shaw's famous retort: "Show me the man before I feel flattered."

Blair was a well-recognized writer for women's journals by the time she started political work. In 1913, she was a club member working on a campaign to build a home to replace the Jasper County poorhouse, which was "a crying disgrace to our humanity." Again, she was baffled as to how she had gotten into the fray, but she found herself making speeches, and "no one was as surprised as I when the Booster Club in a neighboring town jumped en masse to its feet when I had finished." Within months, she was invited to Kansas City to speak. At the time, while the marches were going on along the East Coast, suffrage groups in seven midwestern and western states launched campaigns to gain suffrage on a state level by putting the question to a popular vote. In Montana, Nevada, North Dakota and South Dakota, the groups were pleading with legislatures. In Missouri, Nebraska and Ohio (each with little support from lawmakers), the question was pursued with initiative petitions.

Missouri lawmakers had proved time and again that they were not going to help the women. In September 1912, women traveled to Jefferson City to ask each party for a plank in its state platform for women's suffrage. The Democrats refused. The Republicans added a plank to extend votes to women on local matters of schools.

The Missouri Equal Suffrage Association (MESA) was hard at work. A new and indefatigable corresponding secretary, S.M. Rombauer, had taken charge of the stationery with its magical letterhead. In three months, she reported receiving 127 communications and sending 505 letters and press releases. In contact with twenty newspapers every week, she reported that seven were favorable to suffrage, six unfavorable and seven had made no response. She sent notices to thirty-two libraries, including every St. Louis branch, with "the opportunity to get the history of woman's suffrage in their

collection by payment of express postage." Her three reports to the *Woman's Journal*, a national suffrage magazine, had all been printed. She had also written to Missouri governor Herbert Stanley Hadley for an expression of his opinion on suffrage "and received a reply that he believed in suffrage when the women showed a strong desire for it."

MESA had opened a state headquarters and drafted a petition that read: "We the undersigned, recognize that the women of the State of Missouri are subject to its laws, and believe that they equally with men are entitled to the right of suffrage." On March 18, 1913, the *Kansas City Star* reported, "Suffrage Petitions Are Out: The Women Began Obtaining Signers at Jefferson City This Morning." Obviously, Missouri women had given up working directly with lawmakers. "We are expecting nothing more from this legislature," Cynthella Knefler told the newspaper. "But we will have our initiative petitions completed within a month to get suffrage upon the ballot."

This "yellow petition" campaign, named for the distinctive yellow paper used for the petitions, was the first effort to bring the issue of suffrage to a public vote and the first time that Missouri women used strategy and organization in their efforts to win. They contacted libraries, sending information aimed at helping prepare students for class debates. When the State Library Association announced a pilgrimage to Hannibal, the boyhood home of Mark Twain, MESA created a new piece of publicity, claiming that Twain said to the world, "I would like to see the ballot in the hands of women."

Opposition was still coming from the powerful U.S. Brewers Association and the brewery-related German-American Alliance, which "forcefully and stealthily opposed the measure." Living on the west side of Missouri, Blair may have been unaware of the political situation in St. Louis and Jefferson City. When Helen Guthrie (Mrs. Walter McNab) Miller offered her a job as publicity chairman for MESA, with money to hire a secretary, she jumped at the chance.

The women followed a carefully planned strategy. As members of the WCTU and the many suffrage clubs around the state gained signatures, the petitions were sent to the MESA office. There, volunteers made sure that legislators knew how many had signed from their districts. When an area of the state was found to be weak in its support, the women gave it special emphasis.

When a group endorsed the drive, MESA notified legislators and workers so the endorsement could be used to renew efforts in petitioning. The drive gained support from teachers' organizations, the Farmers Alliance, the Socialist Party, the Progressives, the trade unionists and four state representatives. As MESA ran a speakers' bureau, leagues were organized in new areas—Troy, St. Charles, Warrensburg, Columbia, Jefferson City, California, Farmington, Mexico and Palmyra.

With support came attention from the media and more alliances. From St. Louis came the addition of the Business Women's League, the Jewish Alliance League, the Junior League and groups from Joplin, Springfield, Carthage, Clayton and Webster Groves. After staging a booth at the state fair, MESA added a league from Sedalia. By the end of the drive, the WCTU and MESA members had gathered fourteen thousand signatures, enough to put the measure on the ballot.

Suffragists turned in their petitions and asked lawmakers to call a public vote on the issue in November 1914; resolutions to call the vote were introduced in the House by Mr. Roney of Jasper County and in the senate by Senator Craig of Nodaway County. The issue was assigned to committees on constitutional amendments, and hearings were set. Women spoke at both hearings, and both houses reported favorably with unanimous and enthusiastic endorsement, sending the proposals for a vote from the House and senate for approval. Now the women met with their representatives and counted overwhelming "ayes" for the issue. As MESA reported, "For about four weeks, the suffrage resolution rested quietly, waiting in its due place in the calendar, moving a little closer to the top each day."

A few days before the end of the session, however, Senator Buford, chairman of the constitutional committee, asked the state senate for reconsideration. In response, the senate voted to send the issue back to the committee. This stalling killed the bill. A press release, perhaps written by Emily Blair, explained:

> This is a trick that has been played very seldom and always to avoid being recorded as voting for or against a measure. It will now be impossible, with but one week of the legislative session left, to reconsider the resolution in committee…We repeat, in order to impress it on you, that this issue is taken to avoid being recorded as voting "yes" or "no"…Buford, when asked for an explanation, gave a few hesitant, hedging answers, but finally

drew himself up manfully and magnificently announced "the mothers of the state must be heard from." As a matter of fact, nearly every woman who has been up to the legislature to speak for the resolution is a mother... There was considerable indignation among the dissenting senators, who said freely that they were ashamed to belong to a body so presumably honorable as the senate of the state of Missouri and which had acted in so cowardly a manner.

Just after the close of the legislative session, suffragists held a state convention in Columbia, Boone County, reported to be the only Missouri county with a majority voting for suffrage. The various chapters brought 180 men and women together for a meal; they were welcomed by Dr. R.H. Jesse, former president of the University of Missouri. Edna Fischel (Mrs. George) Gellhorn presided as toastmistress, and Dorothea Dix made the keynote address: "Opportunities for Women in Journalism." The subject, delivered by the ardent suffragist and advice columnist, disappointed the audience eager to hear a suffrage address. She spoke about journalism and mentioned suffrage only twice, but Dix was highlighting the area where suffrage needed to turn its attention. Journalism presented the challenges and the opportunity for women to make great strides.

Just beginning her career in suffrage work, Blair may not have attended the 1914 convention, but she would have understood the message. When MESA decided to publish a monthly magazine, the *Missouri Woman*, Blair took on the job and kept it for two years, when editorial duties were taken over by Mary Semple Scott. By 1916, Blair had become an actor on the national scene, attending conventions and meeting with the respected leaders of the movement. She remembered Dr. Anna Shaw as "a picture on a postcard for Mother's Day" whom men "adored," and Carrie Catt, president of NAWSA from 1900 to 1904 and from 1915 to 1920, as a "very handsome woman" with "an exquisite neck and a line from it to shoulder you never forgot."

It was at a meeting with Carrie Chapman Catt that the idea for the Golden Lane was born. This was probably February 10 or 11, 1916, when Catt visited St. Louis and spoke to five hundred women at the Wednesday Club. The *Missouri Woman* reported, "Plans for a suffrage demonstration during the Democratic National Convention...were made. Suffragists from all over the country will flock there at that time and a large attendance of Missouri suffragists is expected."

Each issue of the *Missouri Woman* brought attention to one aspect of womanhood. The articles came from all over the state, bringing the reader up to date on suffrage events. Besides serious articles about schools and laws that affected women, there were jokes, recipes and hints about homemaking. There were also several pages about the activities of schools and clubs. *Author's collection.*

Blair wrote that Catt had planned a march for the Republican National Convention but thought that Missouri's southern Democrats

> *would not take kindly to women marching in the streets...Why not line the way to the Coliseum with women holding out their hands in mute appeal?... So was born the idea of "the Golden Lane." The women must, of course, look feminine. Very well, they could be dressed in white and carry yellow parasols. Next to a fan, nothing is more feminine than a parasol. And their request? It could be printed on their yellow sashes: "Votes for Women." Nothing unladylike about a yellow sash.*

Blair wrote that the meeting with Mrs. Catt ended at 5:00 p.m., and when they met for dinner two hours later, Catt had a plan written in her notebook. She had figured out the number of women required, the quota to be sent from each state and the number of parasols and sashes to be ordered. "That done," wrote Blair, "Mrs. Catt turned to me and asked, 'How do you suppose they make this cornbread? It's better than ours.'"

9

Wanted: Ten Thousand Women

Five times as many babies die in the crowded tenement districts as in the well-to-do quarters of a city, all because babies, whether rich or poor, demand the same things—sunshine, pure air, pure food and milk, sanitary surroundings and freedom from vice and disease. VOTES—NOT PERSONAL LOVE AND CARE OF THE MOTHER—DETERMINE THESE THINGS.
—*Mary Ashbury McKay, "And So—I Am a Suffragist,"* Missouri Woman *(July 1917)*

In 1916, nominating a presidential candidate was a simple process. Each party held a convention, nominations were made, delegates voted and in a couple of hours the party had a nominee. That year, Chicago hosted the Republican National Convention, and St. Louis hosted the Democrats. Of course, the conventions brought press and attention to the host cities, and to impress the visitors, the city spared no expense. Giant flags flew from the tops of the buildings, drawing the eye to the grand roof treatments silhouetted against the sky. Still more flags flew on poles atop the buildings, and for a few days, the streets were crowded with delegates and spectators wearing their most elegant suits and marching uniforms.

Suffragists were present at both conventions. In Chicago, they marched, and their march was interrupted by a mighty storm. Carrie Chapman Catt later told the *St. Louis Star* that five thousand women marched in Chicago.

Inside the Convention Hall, the League Opposed to Suffrage was just finishing its remarks, saying, "Gentlemen, there is only a small group of women who want the vote," when somebody threw open the doors, and "the women marched in and took possession." They were "drenched to the skin, hats awry, white dresses streaked with yellow and red from their fading banners, shoes slouching cold water at every step, but smiling and cheering and crying 'We want the vote'…They were a pitiful sight, but oh, what an answer they were to the woman who had said, 'Only a small group of women want the vote.'"

Twelve Missouri women had been in the march at the Republican convention, walking almost a mile in the pouring rain, according to the *Star*. The *Star* reported that they had taken a plank, "a Fine, Solid Pine One," and ran a photo of a woman in a very stylish "marching costume," with light-colored trousers (imagine that, trousers!), a long coat, high-button shoes and a wide brim hat. The *Star* did not report that St. Louis women wore that particular outfit, which would have been considered mannish by St. Louis standards.

Charles Evans Hughes was nominated as the Republican candidate for president, and there was a suffrage plank in the platform: "The Republican party, reaffirming its faith in government of the people, by the people, for the people, as a measure of justice to one-half the adult people of this country, favors the extension of the suffrage to women, but recognizes the right of each state to settle this question for itself."

The suffragists hoped, and even dared to expect, that the Democratic platform would have a stronger statement of support. Women from the western states and territories that had been granted the franchise—Alice Paul's "third party"—claimed four million voters. "The votes of 4,000,000 won't go begging," Paul told the *Star*, "we clearly realized that in Chicago." Indeed, the Socialists and the Prohibitionists were seeking the support of the Woman's Party, and the Progressive Party had given women a strong suffrage plank.

As one writer noted, however, four million voters did not translate to four million votes. The number of men who turned out to vote in the presidential election of 1912 was fifteen million out of a possible twenty-five million. Still, as the writer pointed out:

> *It seems quite honorable for the suffragists to whisper in the ear of the hesitating Congressman, "These four million women voters will get you,*

FOR THE ATTENTION OF NATIONAL POLITICAL PARTIES
MORE THAN ONE MILLION WOMEN TO TAKE PART
IN 1918 PRIMARIES
1,079,618 New Women Voters Enrolled for 1918
Primaries In Three States
679,618 in New York State, September Primaries
360,000 in Texas, Primaries July 27th
40,000 in Arkansas as Voted in Primaries on May 28th

This notice appeared in the *Missouri Woman*. *Author's collection.*

*if you don't watch out"…The group of women who are pushing this case
are, without exception, young, attractive, prettily gowned and very feminine.
They have figured, down to the last vote, just how they can swing the
suffrage States against the Democratic Party in this coming election, if their
demands are not granted this week…"If you, Democrats, are suitors for our
hands, you must come bearing gifts," is their attitude.*

The leaders on all sides of the issue were coming to St. Louis, and the
event drew significant attention from the St. Louis press. The *Star* had the
most fun with the information, reporting on page ten, for example, on June
1: "Recruiting for the St. Louis parade went on merrily at the Suffrage Shop,
1006 Locust, today…[the women are] still anxious for some one to lend them
a donkey which can be tied in front of the Suffrage Shop…of gentle, docile
and democratic habits…as one that would hee-haw and kick might mar the
dignity the suffragists insist on maintaining." When a suitable donkey was
found by the *Star*, the paper then sponsored a christening and ran a picture
of two socialites driving it in a cart, an umbrella shading the donkey's head.

The fun of the suffrage preparations on page ten provided a stark contrast
to the news on page one. On June 2, the headline read: "10 British Warships
Sunk by Germans in Battle off Southern Coast of Norway." On June 6,
the paper declared, "Lord Kitchener and Staff Lost on Warship on Way to
Russia When Sunk off Scotland." Kitchener was one of the "most noted
Generals in Europe."

Reservations for the Golden Lane from men and women were coming
in at a reported rate of between seventy-five and one hundred a day.

Interviews with suffragists and anti-suffragists vied for space in the papers. Harriot Blatch made the short trip from Kansas, having moved there when Kansas passed a suffrage amendment for women. Carrie Catt, now fifty-three years old and president of NAWSA, and Alice Paul, of the younger generation at twenty-seven years, explained their differences to reporters. Catt still wanted to pass amendments state by state. Paul still hoped for a federal amendment. Dr. Anna Shaw explained why NAWSA believed Paul's approach would take too long: "If a federal amendment was passed, it then would have to be put up to the individual States. We are working for the States, and when we have a majority of them, it will be a simple matter to get the federal amendment."

Besides delegates to the convention, including women from the suffrage states and female observers, the Coliseum had room for eight thousand spectators, and among the political dignitaries milling about was St. Louis businessman Frederick Dozier Gardner. As a young man of eighteen, one of five children raised by a widower, he had come from Kentucky to St. Louis in one of the waves of migration between those places. He found a city on the rise, with a rising middle class. Modernization was the key to success, from the electrical wires in the walls to the streetcars carrying rush-hour crowds, and this meant modernizing all aspects of life from birth to death. Figuring this out, Gardner put his energy into the high-end funeral business.

A successful casket maker in an era when fancy manufactured goods were replacing home-crafted items, he had a business that put him squarely in the midst of prosperous St. Louis society. His company built the finest caskets, and he knew all the best families and belonged to the most important clubs—the Knights of Pythias, Woodmen of the World, Elks, St. Louis Club, Racquet, Bellerive, Press and Glen Echo. His ties to the Masonic order and historic Tuscan Lodge #360 didn't hurt when it came to business, either. At the same time, he maintained his roots in rural places by investing in farmland. He was sure to be chosen Missouri's Democratic candidate for governor.

The current governor, Elliott Woolfolk Major, a Democrat, had been an embarrassment. The St. Louis press was quite open in its criticism, to the point of ridiculing him. This was not hard to do. Major was a pretentious man, usually appearing in public in a tall stovepipe hat. At the same time, Major had friends, including Champ Clark, Speaker of the U.S. House of Representatives. Major had worked for Clark, who had been an outspoken supporter of women's suffrage since at least 1882.

Wanted: Ten Thousand Women

Gardner, the successful outsider, could save the state for the Democrats. In fact, he was the perfect choice. The trick was to eliminate Governor Major without offending Champ Clark. Major wanted to enter national politics by running for senator against James A. Reed. He certainly would have lost, but to get him out of the way, Reed's men had persuaded Major that Reed would support him as a vice-presidential candidate. A satirical cartoon in the *Post-Dispatch* showed Major, in his hat, balancing on a giant ball inscribed, "Vice Presidential Boom." Although it was probably obvious to onlookers that he had no chance of nomination, the suggestion of Reed's support convinced Major to drop the Senate race.

If Gardner knew this, he didn't show it. A key to Gardner's success was his ability to keep quiet. When still a newcomer to St. Louis, he had learned that an unwise comment could fly through neighborhoods and roost where one least wanted. His years in the funeral business had taught him never to speak ill of anyone. In Missouri, everyone had hidden connections. Gardner rose in business circles, and he wrote enthusiastic articles about the city's future. He had become a respected businessman, and in 1893, he traveled to the ancient cities of Europe, visiting places other people only read about. Then, as an engaged citizen, he addressed the legislature and helped write new banking laws.

Organizers for Gardner had already started working. The Gardner for Governor Club had sent young men to every hotel to welcome delegates, and the James A. Reed political machine had worked its magic on Major. Reed was decidedly against women voting. And Gardner had learned to keep things to himself.

On any other day, a city leader like Gardner would have looked down a St. Louis street and thought about the builders, most of them his friends, who owned the city. He would have been filled with pride, noting how, like the men themselves, each building competed with the one before in terms of elegance and stature. But even with the competition, there was a precision to the scene. The sun threw shadows on the windows and cornices, making a rhythmic pattern. To shade the sidewalk pedestrian, uniformed men came from the shops to roll out canvas awnings and roll them back when the sun moved away. On an ordinary day, the street presented a dance to the proud eye. But with the Golden Lane in place, this was no ordinary day.

For a man less experienced than Gardner, the Golden Lane would have been confusing, even persuasive, demonstrating that the game was up and

there was no excuse for women to be denied the vote any longer. We'll never know what he thought, because for Gardner, suffrage was one thing he'd never talk about. Walking or driving between the lines of women in the Golden Lane, he would have recognized some of the demonstrators as Washington University types. He would have given a slight bow and stood aloof, even as some of the delegates broke rank to shake hands.

These women, with their dresses and parasols, changed everything. The men emerged from breakfast in marching ranks, wearing snappy suits, straw hats and medals announcing their status in their clubs, and then found themselves embarrassed by a row of staring women. Their swaggers gone, the men faced a mile of mothers, grandmothers, aunts and sisters. After the suffragists' years of marching and speaking out, the demonstration seemed to say that they were finished and were not going to move. And the delegates would have to travel between these two stony lines for a mile. There was no break where they might dive out and escape down a side street. And if they had, what shame they would have drawn to themselves.

Then, a few blocks from the hotel, the men encountered another sight. As reported by the *Star*:

> On the steps of the Old Art Museum at Nineteenth and Locust, the delegates saw the "Liberty Tableau," an aggregation of women so arresting that some of the delegates were moved to take off their hats and cheer. At the center of the tableau, the lady "Liberty" posed on a pedestal. On one side, in gray gowns, were 18 women representing the states with partial enfranchisement for women. On the other side, dressed in mourning and with their backs to the viewer, were women representing states with no votes for them. Their heads were bowed and their faces shrouded in black veils. Nearest the front, figures representing fully enfranchised states wore white gowns and women in bright costumes stood for voting countries.

Walking another few blocks, the delegates may have been relieved to hear the noise of the convention coming from the crowd inside the Coliseum. A brass band was playing a medley of patriotic themes, from John Philip Sousa's "Stars and Stripes Forever" to "Dixie." There was a male quartet singing through megaphones, and occasionally the delegates themselves broke into spontaneous song. Governor Major was one of the first to arrive, finding a prominent seat for himself where the delegates could see him in what the *Post-*

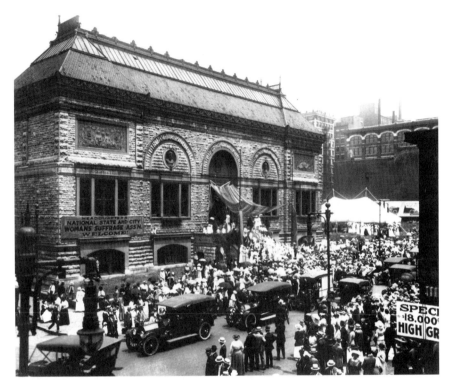

On the steps of the old City Art Museum at Nineteenth and Locust Streets, the *Up to Liberty* tableau stopped traffic and moved the men to cheer. *Missouri History Museum, St. Louis. Swekosky-Notre Dame College Collection.*

Dispatch called his "Prince Albert suit." Then, as every delegation entered, blinking at the sights, there was a roar of enthusiastic cheering as they passed the uniformed firemen and police standing smartly at every entrance.

The organizers had taken care of every detail. Walking to their seats, the crowd passed electric fans blowing across bins of ice. Twenty-three bins were strategically placed around the Coliseum, giving moments of relief from the hot summer day. Drapes of red, white and blue bunting rippled gently, hanging from the ceiling and the balconies. Through the huge skylight, sunshine streamed in on the rows of seating. And if the day were to grow cloudy or the meeting stretched into the evening, no matter. From the ceiling, electric lights hung down on thick electrical cables.

When they found their places and looked around, the delegates saw behind the speaker's table a giant shield in red, white and blue, with the words "America

First" and a portrait of President Wilson. Plaster relief plaques, the likenesses of Democratic presidents and notables, met the eye in every direction. Wilson himself would not be at the convention—he was busy in Washington with the nation's business—but everyone knew he was connected by a private phone line directly from the White House to the Coliseum. Delegates could not help marching a little more quickly, swelling with pride for their party, their modern nation and, indeed, themselves for being part of such an event. The *Star*'s reporter gave a minute-by-minute description, noting that construction work was finished only a half hour before the Coliseum doors were thrown open at 11:15 a.m. for the 12:00 p.m. meeting.

The reporter recorded everything: "A dirty faced, partially clad negro boy found his way into the Coliseum and pre-empted a seat directly in front of the speaker's stand. When the boy was asked how he got in he said that a delegate had carried him in and told him to make himself at home. No effort was made to remove the sole member of the negro race in the sacred precincts of the delegates' seats." As the writer knew, St. Louis usually voted Republican, thanks in part to the black vote, but black voters were becoming disenchanted. The *St. Louis Palladium*, "the Greatest Negro Paper Published in the West," had argued as early as 1907 that Republicans were treating them unfairly:

> *The Negro voters of St. Louis have just cause for complaint against the city central committee on account of the spirit of indifference displayed thus far toward the Negro workers in the Republican party. The Negroes worked hard and earnestly to elect the ticket last year, and by their efforts the Republicans were successful, but when the positions were distributed, out of about 240 places, the Negroes were given six.*
>
> *During a discussion between some of the committeemen and the chairman, Mr. Howe, as to what disposition was to be made concerning the Negro applicants, Mr. Howe remarked: "Oh, let the niggers wait; there are plenty of white men to be cared for"; and the "niggers" have been waiting ever since...Mr. Howe is not much of a Republican, he is at present in charge of the affairs of that party locally, and should have more political sense than to deliberately insult and vilify the 10,000 Negro voters of St. Louis.*

The black vote could turn the election, just as the heavily Democratic rural vote had carried the last one.

Wanted: Ten Thousand Women

"Here is a chronology of incidents in today's opening session," wrote the reporter for the *St. Louis Star.* The *Star* described each delegation as yelling and cheering as it entered, with Missouri, Illinois, New York, Indiana and Pennsylvania seated directly before the platform. The crowd broke spontaneously into song when the band played "Columbia Gem of the Ocean." When the band played "Dixie," there was more applause than for any of the "national and sectional songs." At 12:12 p.m., there was great commotion "at the sight of a hawk-nosed individual, bald, with a graying fringe of hair, dressed in a plain black mohair suit and carrying a roll of paper." It was "Bryan…the great commoner." He produced a small fan and wielded it "vigorously to great applause."

The excitement of the delegates grew as former governor Martin H. Glynn of New York began his keynote address, and the women played their part in raising the pitch. The *Post-Dispatch* reported, "It was one of the women delegates…who started cheering," when Glynn quoted Wilson's policy of maintaining the national honor "by peace if we can, by war if we must." She "sprang to her chair and, waving two flags, began to cheer. Quickly the women joined her and then the men, and in a moment the Coliseum was a-flutter with flags and the cheering lasted four minutes." There were another sixteen minutes of cheering when Glynn predicted Wilson's reelection.

For the hapless Governor Major, however, there was no vice-presidential nomination and, indeed, no mention from the convention floor. The evening *Post-Dispatch* headlined: "Major's Bubble Bursts without even a Report: Governor Fails to Get Mention of Vice Presidency Candidacy before Convention." For Major, it was a mortal wound to his career. He explained, although nobody seemed to believe him, that the plan had been for one of his colleagues to nominate him, and that he would decline, but the plan had been abandoned in the heat of the moment when Vice President Thomas Riley Marshall was renominated by acclamation. The *Post-Dispatch* continued its criticism of Major until the end of his term as governor. So harsh was its criticism that Major supporters asked the newspaper to lighten up, which only supplied the newspaper with more ammunition.

Despite the tension and excitement in the Coliseum as the national Democratic platform was introduced, it offered little for the suffragists. The suffrage plank was unremarkable: "Woman Suffrage. We recommend the extension of the franchise to the women of the country by the States upon

the same terms as to men." In other words, the Democratic Party evaded the question and kicked it back to the states, just as the Republicans had done.

Still, after the plank was read, suffragists in the galleries applauded, and then there were several moments of excitement with a minority report from anti-suffragists. As described by Bertha K. (Mrs. Charles L.) Passmore, first vice chairman of the MESA, Governor Ferguson of Texas presented the minority report: "The Democratic party has always stood for the sovereignty of the several states in the control and regulations of elections. We re-affirm the historic position of our party in this regard and favor continuance of that wise provision of the Federal Constitution which vests in the several states of the union the power to describe the qualifications of their electors." This "minority report," which did not commit the Democratic Party to a position, was applauded loudly by the anti-suffragists. Bolstered by the applause, Ferguson attacked the Resolutions Committee, saying its suffrage plank was "a sop to the Western states" that had approved women voting in the next presidential election.

To this remark, Missouri's popular senator William Joel Stone "sprang to his feet, took the speaker's place and defended the plank." His remarks, Passmore reported, "were incoherent at times." At one time, the "luke-warm suffragist" wavered in his defense by declaring that Missouri did not want votes for women, but shouts from the galleries declared, "Yes, we do! Yes, we do!"

Next, the "brilliant young" senator Key Pittman of Nevada spoke in favor of women voting. Jeered by the anti-suffragists, he burst out, "Are you men, who so bravely and loudly cheer every denunciation of women, afraid to listen to a man say anything in their behalf?" and then defended the many thousands of women working in factories and sweatshops, with no fathers or brothers to vote on their behalf. Next, speaking as a practical politician, Senator Thomas J. Walsh of Montana pointed out that women voters in the pro-suffrage states controlled a good many votes in the electoral college and that every other party had approved women's suffrage.

When the chairman called for a roll-call vote on the anti-suffrage resolution, the votes were called one by one. "The women sat in tense silence until the first few votes were recorded," wrote Passmore, and then it became clear that the delegates would approve the suffrage plank. "Suddenly, one yellow parasol began to wave, then more and more of them were unfurled as the states recorded their 'Noes' until the total of 888½ votes against and

Although there was no particular color associated with suffrage in the earliest years, women generally wore dark, practical clothing. During the California campaign in 1911, the movement adopted yellow as its color. *Author's collection.*

181½ votes for the minority report was announced, when the Coliseum looked as if a field of golden California poppies had suddenly sprung up."

The platform was adopted, and the convention adjourned at 3:11 p.m. The band played "God Be with You till We Meet Again" as the crowd left the Coliseum.

10
The Media Responds

For six hours we stood along the sidewalk, blocks and blocks of us,
women from the tenements and some from New York mansions, teachers
and housewives, factory workers and factory owners. The delegates and
visitors joked us as they took to the streets and marched between us to the
convention; some uncomfortable, some annoyed, and some nodding approval
according to their opinions on the subject.
—Emily Newell Blair, from Bridging Two Eras, *edited by Virginia*
Jean Laas (University of Missouri Press, 1999)

Emily Newell Blair might have been exaggerating about the length of the demonstration. Most observers thought the women stood for two or three hours, but this detail is unimportant. Estimates also vary about the number of women who actually stood in the Golden Lane. What was important was that the women gained attention from the media, and the attention was favorable. The media agreed that the women were the most interesting part of a dull, predetermined convention. In the evening edition of June 16, the *St. Louis Post-Dispatch* ran the following salute:

> *Rows of beautiful Sheroes…miles long, on both sides of the street,*
> *silently and eloquently bespeak the distinguished consideration of*
> *Democracy and mankind.*

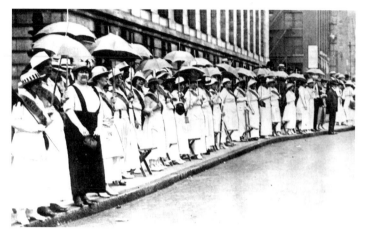

Missouri State Archives.

Time was, ages and ages ago, when the situation on Golden Lane was precisely reversed. The matriarchate, instead of the democracy of males, ruled the world. Woman was possessor of the high estate; man of the low. Woman was center and head of the domestic group, pivot of the social system, boss of politics and leader of militarism. Woman was boss of earth, and the Deity was female. She answered prayers, declared war, led armies, and did the voting exclusively. Men made the best, did the housework, and yearned for political rights. How are the mighty fallen, the menial uplifted! Perhaps woman overdid the overbearing—man has treated her vengefully since he wrested control of politics from her. It seems high time to relent and let her vote again.

She mutely asks Democracy to throw her a plank in the political sea. She asks why shouldn't a female individual have equal rights in a democracy—in a representative government founded upon the consent of the governed! Devotees of liberty and quality, look her in the face and tell her why.

The *Star* reported that the demonstration lasted two hours and consisted of about thirty-two hundred people: "200 Men in Line with 3000 Women in Golden Lane Suffrage Appeal: Probable Fear of Lack of Police Protection Keeps 4000 Enthusiasts Away," said the headline. "Democratic Delegates Pay Respectful Attention to Silent Lines of Vote-Seekers—Color Scheme Very Beautiful." It explained, "At least 7000 women had been expected, but many feared they would be denied police protection, despite assurances to the contrary. They have not forgotten the rough handling of suffragists in Washington, D.C. some years ago."

The Media Responds

The *Star* agreed that the demonstration had been a success: "The women appeared in white dresses, wearing the colors of the suffragists—bright yellow—in the form of hat bands, pennants, scarfs, sashes, belts and flowers. Each woman held a yellow parasol to protect her from the sun." All the major suffrage organizations were represented, and the Democratic delegates were respectful, even enthusiastic. A delegation of "colored" women had joined the group, following the instructions of silence and dressed in the same white and yellow costumes. "All along the line the same respect was paid the earnest women by the visiting delegates."

The morning after the convention, the *Globe-Democrat* published "How the 'Golden Lane' Impressed Woman in Line and Man Who Walked":

By a Woman in Line
As I stood in the ranks of the Golden Lane yesterday, watching the delegates pass on their way to the convention, I was wondering what they thought about us—whether we impressed them favorably or not and I was a trifle nervous when the first carriages began to pass. Four very sober-looking men came up and they neither looked to the right nor left, but straight ahead towards the Coliseum and I was beginning to feel discouraged when one of them raised his hat and smiled right at us. Other girls must have thought he smiled at them because they waved their suffrage pennants. Not another man in the carriage looked our way and so I did not feel altogether happy about it.

But at that moment another carriage came up full of very handsome looking men and they all smiled and looked at us in a very flattering way. They were perfectly grand and I could not help but feel encouraged. It was that way until the last delegate passed only sometimes more than others. Men would cheer and call out, "I am for votes for women," and then we should know that our Golden Lane really had amounted to something.

And as the men seemed to become more and more used to looking at us, they seemed more kindly and cheerful and I really believe they thought we made a very good impression.
By a Man Who Walked.
A heroic little band of women, determined to fight to the last ditch for the right to vote—that's the way the Golden Lane looked to one man who shamefacedly essayed the trip out Locust Street to the Coliseum yesterday. He walked shamefacedly and with his head bowed down because he didn't dare look them in the eye.

Dressed as carefully and tastefully as for an afternoon tea, they sat and stood there on the curbs in the heat and the dust, a silent appeal to the finer instincts of the one with the averted face—and he passed on. He was afraid the boys would kid him for having finer instincts.

He passed banners of yellow with the names of all the states of the Union, held up by little women who were natives of these states. Two hours they stood there, silently, a greater rebuke than any amount of haranguing to the shambling one. He could have turned a deaf ear to shrill recriminations, but he couldn't shut out the subtle, insistent demand of these silent, almost stern, women.

Before he had come to the Coliseum, the badge of suffrage—the little yellow flag—had been pinned on his coat lapel and he had gotten a strangle hold on his sense of superiority. He walked on with a strange and unaccustomed feeling of wellbeing. That's what happened to the man who walked the length of the Golden Lane.

After the Golden Lane disbanded and while the delegates were meeting, the suffragists met at the Old Art Museum. The *Missouri Woman* reported: "Every seat in the house was filled long before 3 o'clock when Mrs. J.M. Leighty, state president of the Missouri Equal Suffrage Association, took charge." Dr. Anna Shaw was the principal speaker, and the group was honored with a visit from William Jennings Bryan, who had come from the convention. Bryan was an elder now and had little power, but the suffragists appreciated his years of work on their behalf, and they cheered as he said he would do what he could to assist the suffrage cause in this, its final battle. He added that he was preoccupied with the war in Europe, "a man-made war and…women are not in favor of it."

The next day, the *Globe-Democrat* published an anonymous poem surrounded by a page of photos of the event:

Citizen and Democrat
Marching down the Golden Lane
'Neath the eyes of Mrs. Catt
Marching down the Golden Lane.
Marching out to nominate
Wilson for their candidate,
How the Democrats did hate
Marching down the Golden Lane!

The Media Responds

SILENCE! My but it did talk.
 Marching down the Golden Lane.
Fast the delegates did walk
 Marching down the Golden Lane.
But they couldn't get away
From the "Women's Votes" display;
They'll recall for many a day
 Marching down the Golden Lane.

Barnes was there and Major, too,
 Marching down the Golden Lane.
Wond'ring what they ought to do
 Marching down the Golden Lane
Didn't dare to look aroun'
Kept their eyes close to the groun'
Like that old Missouri houn',
 Marching down the Golden Lane.

But there wasn't any plank
 Marching down the Golden Lane.
Not a "Votes for Women" crank
 Marching down the Golden Lane
See that heckled-looking man?
No, he's not a suffrage fan,
But a poor committeeman,
 Marching down the Golden Lane.

Maid and matron suffragette
 Stood along the Golden Lane.
Trying every vote to get
 As it passed on down the Lane
But the bands began to play
And the marches hiked away—
Next convention they'll not stay
 To march along the Golden Lane.

In the golden age of illustration, Rose O'Neill invented the kewpie, a character that she could transform to fit any situation. O'Neill was born in Pennsylvania in 1874. Her family moved to a homestead in Nebraska and then to the Missouri Ozarks. As a young woman, Rose landed in New York City, where she became the most successful female artist of all time. Later in life, she moved back to Missouri. *Undated drawing, probably about 1910. Missouri History Museum, St. Louis.*

If the suffragists were disappointed by the weak plank in the Democratic platform, they didn't let it get them down. The July 1916 issue of the *Missouri Woman* opened with an article by Helen Guthrie Miller, declaring June a "red-letter month in the suffrage calendar." Miller announced that NAWSA would contact every man in Congress to determine his opinion on a federal amendment. She encouraged women to send letters and telegrams to call on Congress to pass a federal amendment and then to work for ratification from the states. "When one thinks that for forty-eight years an appeal has been made at each National Convention…with no result," Miller reminded readers, "the endorsement this year marks a distinct advance in the progress of the cause, and now it is up to the individual suffragist to do her part." Following the theme that women can work with anything, Mary E. Bulkley wrote:

> *Is not what a woman will do with a button hook and a hair pin a proverb? The same willingness to "get along with" any old sort of implement, to cook in a tomato can, to use a fork for a corkscrew and her apron for a hot dish holder, shows…that her desires and beliefs are a factor in influencing public opinion without the ballot. It can be done. It is done…but all too often at terrible expense of time, strength and dignity…In these modern days this is too inefficient to prevail for long. Women must use the ballot.*

11

What Next?

As the 1916 presidential campaign and the war in Europe heated up, stories about votes for women fell off the St. Louis newspaper pages. The *Post-Dispatch* used precious inches explaining a fascinatingly modern system for alerting the public the moment it learned which presidential candidate was elected. The electric companies would flicker the lights on all their lines—once if Wilson won and three times for Hughes. At the same time, every factory and railroad yard with a whistle would blow their whistles, once for Wilson or six times for Hughes. This distraction proved the newspaper's own power and gave readers relief from the bad news from Europe. But explaining the notification system did nothing to educate the public on the issues. A new issue was gaining attention, especially in St. Louis. In the November election, voters would see a state prohibition question on the ballot. Amendment Three, a constitutional amendment, had been proposed:

> *Section 1. From and after July first, 1917, no intoxicating liquor or liquors, except wine for sacramental purposes, shall be manufactured in or introduced into the State of Missouri under any pretense. Every person who sells, exchanges, gives, barters or disposes of intoxicating liquor of any kind to any person in the State of Missouri, or who manufactures, or introduces into, or attempts to introduce into the State of Missouri, intoxicating liquor of any kind, shall be guilty of a misdemeanor.*

Churchgoing rural voters and Progressive Democrats would vote for prohibition. Both parties were divided by "wets" and "drys." But in St. Louis, beer was big business, and the Busch family was still the first family. Rural voters outnumbered urban, so to defeat Amendment Three, the Busch team worked to bring St. Louis Republicans to the polls, hoping they would vote against it. This would mean votes for Henry Lamm—a "wet" Republican— for governor.

Staying away from controversy, prohibition was another thing Gardner refused to discuss. His issues appealed to rural voters—better roads, more credit for farmers. In an unusual move, Gardner mailed letters to every Republican voter in St. Louis, arguing that he was a city man but had strong ties to the country. He could bring the factions together. Gardner was endorsed by the *Post-Dispatch* for demonstrating his "liberality, executive ability and progressive spirit."

Four days before the election, a committee of ten "wet" Democrats visited Gardner and insisted on a statement about the liquor question. They were alarmed that he might lose voters in the brewery wards unless he made a statement. Gardner said he would veto any prohibition amendment, and his statement turned many "dry" Democrats against him. If he had spoken earlier, onlookers agreed, his statement would have gotten to rural districts and cost him the election because he would have lost votes to the only "dry" in the race, Progressive Joseph Fontron.

The election was a squeaker. Lamm carried St. Louis County, but Gardner was in the lead elsewhere, and after recounts in several counties, Gardner ended in the lead with 2,692 votes. He proceeded with inauguration plans. A front-page cartoon in the *Post-Dispatch* depicted Gardner as a yogi, cross-legged on a pillow, with supplicants labeled "Please help the poor," "Drys," "We want jobs," "Don't overlook the Old Guard," "Wets" and "Ballot Probe." A cartoon figure in the border proclaimed, "Count 'em!" The headline proclaimed, "Whom the Gods Would Destroy, They First Make Mad."

Gardner was accused of gross fraud. Lamm's people protested until the day of the inaugural ceremony and swore they would pursue the matter with the General Assembly and remove Gardner after the inauguration. Gardner, when interviewed, "said that it was unnecessary for him to say anything, as both sides had signified a willingness to have a contest. He added that he did not want the time of the Legislature taken up with 'bunk.'"

What Next?

On the national level, Woodrow Wilson narrowly defeated Republican Charles Evans Hughes. Until the California votes were counted, Hughes had a slim lead and reportedly went to bed thinking he had won. A popular story from the election recounts that a reporter called the next morning for an interview, and someone in the Hughes home answered by saying, "The President is sleeping." "When he awakes," said the reporter, "tell him he ain't President."

Both state and national elections were dramatic, and neither ended with a strong suffrage man in power. The president could ignore the suffrage issue by becoming preoccupied with the war in Europe, even though Alice Paul's National Woman's Party had started picketing the White House on January 10, 1917, putting suffrage demonstrators at his front gate every day. But in Missouri, Gardner was the governor, and suffrage was a subject he still would not discuss.

Controversy over the Missouri election and accusations of campaign fraud lasted through the inauguration, which would be the first in the new capitol. "The floral decorations alone for the West Museum on the first floor…cost more than $1500," reported the *Post-Dispatch*. When the January day turned warm and thousands of spectators arrived, the ceremony was moved outdoors. At 12:15 p.m., the band, playing "Dixie," heralded the Kentucky-born governor-elect. "I want to be a builder," he told the crowd in a forty-minute speech:

> *I want to build up a great machine, not a personal, not a political machine, and at this time I want to take occasion to again say that I shall never be a candidate for another office. I do not wish to be influenced by personal or political influences. I want to act at all times calmly and deliberately. Will you uphold my hands? Will you co-operate with me? Will you help me?*

Among his goals were putting the state on firm financial footing, new taxation and improving roads by creating a Department of Transportation for the state. The new department was necessary to get federal highway funds. And Governor Gardner was not ineffective. His administration was able to "lift Missouri out of the mud" in a successful campaign to bring good roads to all corners of the state.

He did not mention women's suffrage, and his New York–born wife, Jeannette, was equally mute on the issue. She devoted herself to bringing

style to Jefferson City. The *Post-Dispatch* described the inaugural ball, held at the mansion, and emphasized details that made it a glamorous and up-to-date affair. The paper's coverage reminds us that, indeed, the jazz age was born in Missouri and carried to New York by Kansas City bands:

> *The one-step was the first dance. The fox trot was a favorite. The one-step and the fox trot were danced almost exclusively. When the "Toddle" was suggested, the elite of Jefferson City turned up their noses. The "Toddle" is presumed to be the very latest thing from New York. Jefferson City dance artists said the "Toddle" was discarded in these parts about four years ago. They said it was known as the "jingle."*

Prohibition had not passed, but Gardner ordered no alcohol for the inauguration. Still, one supporter sent a case of wine, which was poured by the harried servers into some glasses but not others. Jerena East Giffen reported in *First Ladies of Missouri* that "little comedies were enacted every time a fresh tray was brought into a room…the first taste was followed by a happy smile or a resigned frown."

Jeannette Gardner wore an elegant silver ball gown that swept the floor, with a cream-colored train decorated with silver flowers and rhinestones. Wearing a string of pearls and carrying a bouquet of orchids, the first lady stole the show. One writer noted, "She has the money to entertain on any scale she pleases."

Fashion was a fine thing, but suffragists were focused on their work. If they had had a few chips to barter with lawmakers, the job would have been easier. The Republican charges of election fraud were settled when Democrats promised to drop their pursuit of Republicans behaving badly in the St. Louis courts. The *Post-Dispatch* reported that the agreement was "You tickle us and we'll tickle you," and "Gardner said he had nothing to say and would continue to have nothing to say."

Determined to pass a statewide suffrage bill in the General Assembly, to be signed by the governor in 1917, MESA reached out for help from women in all areas. The *Missouri Woman* produced a special issue for farm women and then one for secretaries. Mrs. John Leighty, state chairman, spent much of the 1917 legislative session in Jefferson City. The women managed to get a suffrage bill introduced in the House, where it became Bill 792, and the senate, where it was number 478. The *Missouri Woman* covered their efforts

closely and published the names of lawmakers voting for and against. "If by chance your representative is amongst those who voted 'No' you will have to convert him most quickly," wrote Bertha Passmore, state congressional chairwoman for MESA.

The governor had finally endorsed women's right to vote at a meeting in Sedalia. His wife also spoke briefly, stating her agreement. But she concluded by saying, "I have never made a political speech. I never intend to make one. If I have gotten my husband any votes, it has not been by talking but by keeping still."

Yet there are many steps to bringing a bill through the Missouri General Assembly—and many ways it can pass or be stalled. A committee called the Senate Committee on Privileges and Elections, which seems to have existed only for Bill 478, voted not to let it out of its meeting. One senator, however, obtained enough support to override the committee, and the bill appeared on the senate calendar. Meanwhile, Bill 792 was working its way through the House.

Women were writing letters and calling lawmakers—who did not represent the women, of course, but their husbands. "Men of Missouri," an unsigned notice in the *Missouri Woman* declaimed, "can you afford to deny the ballot to the women of Missouri when women are voting in the states to the East of you, in the states to the North of you, and in the states to the South of you?"

House Bill 792 passed on a Friday, after the senate had adjourned, which meant more delay. When the senate returned, the committee added an amendment and passed it to the floor. The amendment would have allowed votes for women, but in separate polling booths and with separate election judges at each polling place. The expense would have been two times the expense of prior elections.

A week later, the senate bill was scheduled for a final vote in the first session on Monday morning. A call went out, and the excited suffragists from St. Louis started for Jefferson City. Arriving, they were met by Mrs. Leighty, who carried the sad news that the senate had passed a resolution to hear nothing more but appropriations bills. When the senate met again, it read a few messages, including the governor's acceptance of adjournment of the session, and adjourned.

Bertha Passmore concluded: "If devoted, hard, unceasing work and tremendous loyalty and support from all over the state, during the time our struggle was on at Jefferson City, could have won the palm of victory, it would

have been ours. That our bill met defeat was due to the utter determination of a minority in the Senate not to let it come up."

Once again, the legislature had disappointed, but the women responded with new energy. St. Louis women set up a speakers' bureau, and volunteers added weekly lessons in speechmaking to their schedules. Besides this serious work, there was some amusement. At the annual luncheon, Miss Mary E. Bulkley, a mezzo-soprano, sang a new song, with apologies to the shade of Stephen Foster, "Old Black Mo":

> *Dark are the days, tho' they hadn't ought to be,*
> *Suffrage is coming and coming rapidly;*
> *The map is growin' white, the East begins to glow,*
> *But on this map we still are seeing, Old Black Mo.*

Meeting reports tell us the "entire assemblage" joined in the chorus:

> *It's coming! It's coming! See how the white spots grow!*
> *We hear our happy sisters calling Old Black Mo.*

Bulkley continued:

> *That's why we weep and our hearts are full of pain.*
> *Cold-hearted politicians have knocked us out again.*
> *The Federal Amendment is so infernal slow*
> *And on the map we still are seeing Old Black Mo.*

> *Chorus*

> *When two years pass, once more we'll try it on.*
> *Some who opposed us will certainly be gone.*
> *We'll be good and ready and then perhaps we'll show*
> *A spot of white instead of Old Black Mo.*

> *Chorus*

Suffrage Work Is War Work

So if you are a mother of a boy at the front, or a wife or a sister of a man in France, and live in the Tenth Congressional District, your interests in momentous national war legislation will have no consideration at the hands of your so-called representative in the Congress.
—Lucille Lowenstein, "Federal Suffrage Amendment Day in St. Louis,"
Missouri Woman *(December 1917)*

By the middle of 1917, the United States had entered the war in Europe. For the suffragists, this brought more controversy and more dissension between Carrie Catt's National American Woman Suffrage Association and Alice Paul's National Woman's Party. As a whole, there was much for both sides to agree on. Both groups were firmly committed to passing the Susan B. Anthony amendment—and to having it ratified by thirty-six states in time for the next presidential election. Catt considered it patriotic to struggle for the vote, saying, "This is war work." But she considered the NWP's White House pickets to be inflammatory. She wrote to Paul, "An unwarranted discourtesy to the President and a futile annoyance to the members of Congress…the presence of the pickets is hurting our cause in Congress."

The House had agreed to vote on creating a committee on women's suffrage. The idea gained the cooperation of the Speaker and a statement from President Wilson. Both suffrage groups sent speakers to the hearings,

but at least one lawmaker declared he would never vote for the committee if the pickets stayed in place. "I urge you," Catt wrote to Paul, "to make our progress easier by removing your pickets, and with them a cause of hostility in the minds of people who would otherwise be friends."

Back in St. Louis, women were pitching in to sell Liberty Bonds and spread the message of the war effort. Their position as volunteers without votes was not lost on them. As Miller wrote, "In a world war fought for democratic control, our position is a bit anomalous, but we trust our men to put that right in the next session of Congress." With their men fighting in France, women were increasingly aware of their own sacrifices, and increasingly indignant that anyone might doubt their patriotism. Calling the home "the second line of defense," Edna Gellhorn became chairwoman of the Women's Committee on Food Conservation. The *Missouri Woman* ran recipes for foods that substituted abundant homegrown ingredients for

September **The** 1917

Missouri Woman

Edited by MARY SEMPLE SCOTT

those becoming scarce in efforts to feed the troops. Meatless days at home and fresh, home-raised vegetables meant that the nation's canneries could produce for the men on the front lines.

While they were occupied with the war effort, the St. Louis suffragists also put their efforts into passing a national amendment. On November 16, 1917, they launched a campaign to force Missouri's congressmen to vote for the Susan B. Anthony amendment. With a year until the midterm elections, they planned to work against lawmakers who did not support suffrage. Visiting the offices of congressmen Jacob Edwin Meeker, William L. Igoe and David P. Dyer in St. Louis, delegations of women secured pledges of help from Igoe and Dyer but insult from Meeker.

The delegation to Meeker's office, with representatives from every ward in Meeker's district, was led by Mrs. Miller, accompanied by Erma Kingsbacher (Mrs. Ernest W.) Stix and Bertha Passmore. "I know what you want, but my answer is 'no,'" Meeker told them when he arrived, late, to the meeting, Lucille B. Lowenstein reported in the *Missouri Woman*. "I am against suffrage—my district is against it, and it's all nonsensical, anyway," Meeker continued. "Hundreds of women in my district may come to see me, but I only consider the voters…Effeminizing the nation will never lick the Kaiser." Delegations to Igoe and Dyer had better luck when suffragists argued that the fight in Europe was about democracy, while American women were still not granted fundamental rights.

The women gathered at a luncheon after the meetings, with Mrs. Stix as hostess. She introduced Melville Wilkinson, chairman of the Missouri Council of National Defense (CND) and employer of large numbers of women in his dry goods business. He said that women in business were the equals of men. George Odell, director of the Ethical Society, reported seeing posters in New York saying, "Let America Lead. England and Russia have promised women the vote." Mrs. B.F. Bush, chairwoman of the women's division of the Missouri CND, agreed that a woman's place was no longer only in the home.

Wrapping things up, Congressman Dyer promised to vote with the suffragists. State representative William J. Blesse promised to support ratification if the amendment passed in Washington. Buoyed by these promises, the women looked forward to the congressional session. Fourteen women, from all parts of the state, made plans to attend the forty-ninth NAWSA convention a month later in Washington, D.C.

Congress had been in session little more than a week when NAWSA suffragists from every state descended on the Capitol. The Big Drive on Wednesday, December 12, forced all lawmakers to meet with suffragists from their districts. For Missourians, the meeting brought strategic members of Congress together. Missouri's Champ Clark, Speaker of the House, supported the amendment, but the Speaker only votes in the case of a tiebreaker. Missouri was also home to two popular and powerful senators: James A. Reed, who had spoken frequently against votes for women, and William Joel Stone, the "luke-warm suffragist," a friend of the Gardners and a rising star in the Democratic Party.

The Missouri delegation was composed of eight St. Louis women: Mrs. Stix; Mrs. Lowenstein; Bertha K. Passmore; Miss Mary Lionberger; Grace Richards (Mrs. Robert McKittrick) Jones; Florence (Mrs. Frederick J.) Taussig, a close friend of Jane Addams; Mrs. Robert Crabb, sister of publisher Edward Lewis; and Barbara (Mrs. David) O'Neil, according to the *Post-Dispatch*, "a tall, statuesque matron, very dignified, said to be a shrewd judge of men, with intuitive insight into their machinations." From Kansas City came Vassie James (Mrs. Hugh C.) Ward and Blanche Janet Hess (Mrs. Jules) Rosenberger. For the first time, smaller towns were represented in the effort, by Mrs. D. Cooney of Marshall; Miss Ellen T. James of St. Joseph; Mrs. Helen Guthrie Miller of Columbia; and Mrs. William R. Haight of Brandsville, who was described by the *Post-Dispatch* as "a woman of leisure, means and the talent to make herself available in many emergencies." The delegation met with lawmakers in Senator Stone's office. Reed and Meeker were not present.

After their meetings, women from each state reported their results. Arkansas women had met with President Wilson, and he supported them. New York, Ohio, Virginia and Maryland all reported good meetings. The *Missouri Woman* reported that the entire body accepted the resolution of the Executive Council, calling on Congress to enact the federal suffrage amendment as a war measure. "If Congress fails, the National American Woman Suffrage Association will select and enter into such a number of senatorial and congressional campaigns as will effect a change in both houses of Congress."

Less than a month after the Big Drive, on January 9, 1918, President Wilson announced his support of the Susan B. Anthony amendment. Newspapers backed the president with favorable editorials. An estimated

850 editorials were written, with only 5 hostile. In fact, the NAWSA had discontinued efforts to convert editors because they were all converted.

The day after Wilson announced his support, the House of Representatives, with Champ Clark as Speaker, passed the bill. But still, the Senate refused to debate it. With midterm elections in November, the NWP launched a campaign to oust the anti-suffrage senators. In Missouri, suffragists dedicated themselves to selling Liberty Bonds, showing national patriotism and support for the war effort and planning a petition drive to bring the issue back to the Missouri legislature.

The threat to oust anti-suffragist senators worked. A month before the midterm elections, the U.S. Senate began debating the Susan B. Anthony amendment. At the same time, St. Louis women began gathering names to ask Missouri lawmakers to allow women to vote in the 1919 presidential election. Women from every district called their representatives and senators, urging them to pass the bill. When the legislature convened in January, a vast majority of lawmakers had agreed to vote yes. Mrs. O'Neil, Mrs. Haight and Mrs. Miller prepared for a long session in Jefferson City. In both the senate and the House of Representatives, suffrage bills were the first to be introduced. Bill 1 passed the Missouri Senate on March 28, 1919, by a vote of twenty-one to twelve. A vote was called by the House for April 4.

At the time, the National Suffrage Convention was meeting in St. Louis. After the opening banquet, Mrs. Miller, Mrs. O'Neil, Mrs. Haight and Miss Marie B. Ames snuck away to Jefferson City, taking a midnight train. They returned triumphantly with the news: Bill 1 had passed in the Missouri House, and Governor Gardner had signed it. Missouri women would be able to register and vote in the presidential election. "On receipt of the news the whole National Convention rose to its feet and cheered—cheered loud and long," reported the *Missouri Woman*. Three cheers were called for each officer, for the *Missouri Woman* and for Mrs. Gellhorn,

> *and they came, lustily, until human throats could cheer no more...An impromptu Indian file march was staged also around the lunch room. A banner appeared from nowhere with "Now We Can Vote" on it to be carried in the lead, buttons inscribed with "I'm a Voter" adorned every coat lapel, and old and young joined joyously in the celebration march.*

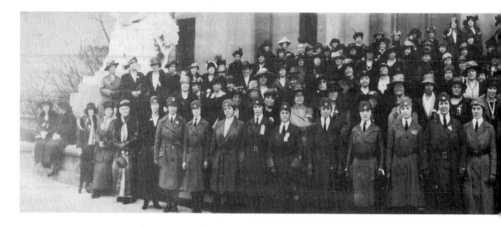

"Now we can vote!" The National Suffrage Convention was meeting in St. Louis when the state passed the suffrage bill. These women are serious for their photo but broke out in joyful dancing when Missouri adopted suffrage with an amendment to the Missouri Constitution. *Library of Congress.*

Reporting on the bill's passage several days later, *Post-Dispatch* writer Marguerite Martyn embellished the story, and the *Post-Dispatch* cartoonist supplied illustrations. According to their version, at the last minute, the suffragists realized that two important voters were missing. They made urgent calls to Senator Stark and Senator Gray, asking them to come immediately to the capitol. Gray, a judge, left the courtroom hastily without hearing the jury's verdict and climbed into "a special train arranged for by the women." Stark rode "all night in a fast motor car over six counties" and slipped into his senate seat the next morning, wearing overalls and a "hickory shirt." The session might have opened without Gray in his seat, but Mrs. O'Neil, Mrs. Haight and Mrs. Miller detained Lieutenant Governor Crossley, who "must have wondered how three women could be so entertaining and full of good but inappropos stories on a morning when they had so much at stake." Senator Gray arrived and was seated, "and the opposition [was] flabbergasted." This is a great story. We have to wonder why it wasn't covered in the *Missouri Woman.*

Perhaps the answer is that the Missouri news was eclipsed by events in Washington, D.C. The Susan B. Anthony amendment had been introduced again, renamed the Federal Suffrage Amendment. It was stalled again, but by this time most members of Congress were pro-suffrage. Just five weeks after the Missouri law was signed, the U.S. House of Representatives finally approved votes for women, 304 to 89. The Senate followed on June 4 and approved it by 56 votes to 25.

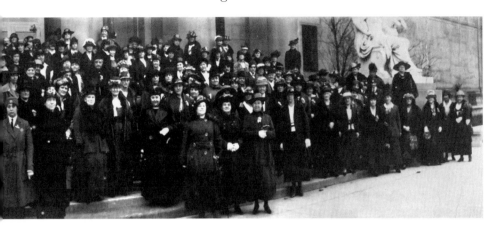

After years of foot-dragging by Missouri lawmakers, the ratification of the national amendment went quickly. The state Republican Central Committee had already endorsed it before it was passed by Congress. The suffragists arranged a debate with anti-suffragists in front of the Missouri Democratic Central Committee, with Mrs. Stix and Mrs. Miller speaking for the suffragists. Mrs. Stix presented five reasons for the committee to endorse suffrage:

> *First: President Wilson has urged it as a war measure, 14 members of the House from Missouri voted for it;*
> *Second: The Democratic and Republican National Committees have gone on record as favoring it;*
> *Third: Eleven million women are qualified to vote in the United States;*
> *Fourth: A large preponderance of local and state sentiment is in favor;*
> *Fifth: Women have secured the right as a reward for their work on behalf of the Red Cross, food conservation, Liberty Bond sales and other war activities.*

The resolution passed with a large majority, clearing the way for ratification in Missouri.

Now, many more states rushed to ratify the new amendment. Illinois, Michigan and Wisconsin ratified it within a week, followed by Kansas, New York and Ohio. By the time Governor Gardner called a special session of the legislature, Missouri was racing Iowa to be the tenth state to ratify. In all, 305 women came to Jefferson City for a dinner before the special session. Governor Gardner was principal speaker, accompanied by politicians from both parties, speaking about the contributions women would soon make.

Ratification would have taken place on July 2, but another twist changed the fate of the law when Senator Clark Wix of Butler County died. He had been a friend of the suffrage movement, and in respect, the senate postponed its session. Still, the House galleries were packed with suffragists in a happy mood, wearing colorful summer dresses. The House passed ratification quickly, with only four votes against. Speaker Sam O'Fallon's announcement was greeted with yells and applause led by Representative Jones H. Parker of St. Louis and joined by those in the galleries.

At ten o'clock in the morning on July 3, the senate galleries were packed with suffragists, and again the vote went quickly. Suddenly, all the men were supportive, vying for the votes that women would cast in the next election campaigns. The senate passed the bill with three negative votes, one abstention and one absentee. Just minutes after the passage, Mrs. Gellhorn received a telegram that Iowa had beat Missouri to ratification, finalizing its votes minutes earlier, but Speaker O'Fallon noted that Missouri still beat Iowa because Iowa had five votes against and Missouri had only four.

Governor Gardner signed the ratification almost immediately. In everything he did, there was an atmosphere of heightened excitement. Photographers, journalists and a crowd of the bill's supporters came to the signing. The room was full. A few men worked their way into the room, looking like prom dates in their business clothes. Women of all ages packed in—some in huge spring bonnets and some bareheaded. For the younger women, their bobbed hairdos, bare heads and even a few bare necks were already a celebration of new freedoms of the era. With no ruffle or laced collar in sight, these women were the daughters or granddaughters of the women who had started the fight for suffrage years before. And they were jubilant.

Only one woman wore the uniform adopted by suffragists for formal events: a black coat and skirt, white shirt with high collar, black bow tie and black silk sailor hat. Mrs. Gardner recalled later that her daughter, Janet, was intrigued by the costume. But most of the suffragists in the room had decided to be modern.

Putting pen to paper, perhaps Governor Gardner was thinking about the momentous social change he was signing into law. Or perhaps his mind was more on the golf course. "Each day, he would return to the Mansion during the lunch hour, use the back stairs, have a light lunch in his bedroom, and head for the country club," wrote Jean Carnahan in *If Walls Could Talk*. And

Governor Gardner signs the ratification of the Federal Suffrage Amendment. On the huge table in the governor's office, there is a pitcher of black-eyed Susans, perhaps picked from a pasture near Jefferson City or from the governor's own garden. This feminine touch dominates the room. Clearly, the women had arrived. Gardner, on the other hand, appears to be dressed for a golf game. *Library of Congress.*

Mrs. Gardner helped by deflecting her guests' interest in his whereabouts: "Deftly as possible, I would change the subject. 'My dear, won't you have another chop?' I would say."

So, on July 3, 1919, Missouri became the eleventh state to ratify the suffrage amendment. In August, the *Missouri Woman* reported:

> *The historic yellow suffrage parasols, harbingers of victory and outriders of success wherever they have put in an appearance, figured prominently in the special session of the Legislature at Jefferson City...the women owners carrying them in procession...through the cool corridors of the capitol building and unfurling them, victorious and ever triumphant, in the galleries of the House when the roll call proved that Missouri Legislature had ratified the Federal Suffrage Amendment.*

To Learn More about Missouri, Women's History, St. Louis and the Golden Lane

Learning about women's history is a joy, and as you realize what's been left out, you may have fun reading about history. Carrie Chapman Catt estimated that, just to get the vote, women launched 56 referendum campaigns, 480 legislative campaigns, 47 campaigns for constitutional conventions, 277 state party conventions, 30 national conventions and 19 campaigns with nineteen U.S. Congresses, and almost none of it is covered in any standard history text book.

To help you catch up, the University of Missouri Press has issued the excellent Missouri Heritage Series, edited by Rebecca Schroeder. Each book focuses on a biography or a historical theme, following the subject through time. Several women have been profiled in these books. Two of the books—*Called to Courage* and *Into the Spotlight*—are coauthored by Margot Ford McMillen and her daughter, Heather Roberson. That said, there has been a shocking lack of documentation about the Golden Lane, except for articles in a few academic journals. One brave exception, Katharine T. Corbett's book *In Her Place* (Missouri Historical Society Press Guidebook, 1999), gives it a few pages, and the Missouri History Museum has issued a nice web page on the Golden Lane. As the centennial draws close—in 2016—we hope it will get the attention it deserves.

The tradition of men's and women's spheres dominated social thought for nearly two centuries. The theme of how women are to fit into a man's world

is part of literature from the Civil War until the 1960s and beyond. One important entry is St. Louis author Kate Chopin's *The Awakening* (written 1897–98, published 1899). Chopin describes her character: "Even as a child she had lived her own small life all within herself. At a very early period she had apprehended instinctively the dual life—that outward existence which conforms, the inner life which questions…It seemed to her as if life were passing by, leaving its promise broken and unfulfilled."

The Minor case is probably the best-covered episode in the history of St. Louis women. An essay by Lee Ann Whites in *Women in Missouri History* (University of Missouri Press, 2004) gives a good description of the Minors' fight for women's rights. *The Dictionary of Missouri Biography* (University of Missouri Press, 1999) contains brief biographies of many of the leaders of active Civil War organizations. Besides Virginia Minor, the dictionary covers Anna Clapp, Adaline and Phoebe Couzins and James Yeatman, to name just a few. There are also two volumes of biographies of women in *Show Me Missouri Women*, edited by Mary K. Dains (Thomas Jefferson University Press, 1989 and 1993). Many St. Louis websites (including that of the Old Courthouse) carry articles about the Virginia Minor case.

The women's clubs and organizations that sprung up in St. Louis are covered in *In Her Place*, edited by Katharine T. Corbett (Missouri Historical Society Press Guidebook, 1999). While many of the clubs have disappeared, the most well funded have endured, including the Wednesday Club and the St. Louis Women's Club. Others have left archives in one or more of Missouri's many repositories—the local historical societies, state historical societies or the Western Historical Manuscripts Collections. And, of course, the communities founded by publisher Edward Gardner Lewis have endured and are well represented in St. Louis history books and web pages.

The scrapbooks and correspondence of many women like Florence Usher can be found in archives in the state. There are also collections of photographs, diaries and scrapbooks in almost every county historical society. Other archives are the State Archive in Jefferson City, the State Historical Society in Columbia and the Missouri Historical Society in St. Louis.

The national marches for suffrage were covered by the national media and have been examined and reexamined by scholars, so there are many sources to learn more about them. Besides printed materials, there is an interesting Hollywood film entitled *Iron-Jawed Angels*, released in 2004 by HBO and starring Hilary Swank. It is well worth the rental fee, and if you

To Learn More...

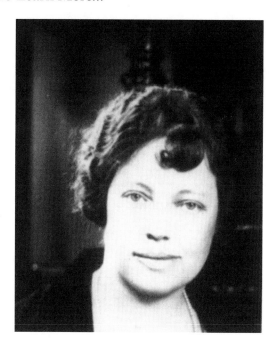

Marie Byrum of Hannibal is officially recognized as the first woman voter in Missouri. *Missouri State Archives.*

were thinking of withholding your vote from the next election, the dramatic scenes of forced feedings and wormy breakfast gruel will help you consider the courage of the women who won the franchise on your behalf.

Emily Newell Blair left boxes of papers behind, including several versions of her life story. Virginia Laas brought them together into a cohesive whole, *Bridging Two Eras: The Autobiography of Emily Newell Blair, 1877–1951* (University of Missouri Press, 1999). Reading about her gives the reader a feel for the era as Missouri was industrializing, for life in a town that was important but far from major urban areas and for concerns of women at a time when opportunity was exciting but at the same time scary. The *Missouri Woman* has been saved on microfilm by the Missouri Historical Society in St. Louis, and some issues are available on microfilm at the State Historical Society in Columbia.

Finally, the wives of the governors have been covered, briefly but well, in two books. *First Ladies of Missouri* by Jerena East Giffen was published in 1970 and reissued in 1996 by Giffen Enterprises in Jefferson City. *If Walls Could Talk* by Jean Carnahan was published in 1998 by Missouri Mansion Preservation.

Index

INDEX

About the Author

Margot Ford McMillen has written six books and numerous articles about Missouri issues—heritage, women, conservation and history. Besides writing and teaching, she is a farmer and raises food for Missouri restaurants and stores. She lives with her husband, Dr. Howard Wight Marshall, in Callaway County.

Howard Wight Marshall photo.

Visit us at
www.historypress.net